ART 7

FOR YOUNG CATHOLICS

WRITTEN BY
SETON STAFF

SETON PRESS
FRONT ROYAL, VA

Executive Editor: Dr. Mary Kay Clark
Editors: Seton Staff

Seton Home Study School
1350 Progress Drive
Front Royal, VA 22630
540-636-9990
540-636-1602 fax

For more information, visit us on the Web at www.setonhome.org.
Contact us by e-mail at info@setonhome.org.

ISBN: 978-1-60704-133-7

Cover: *In the Villages the Sick Were Brought Unto Him*, James Tissot

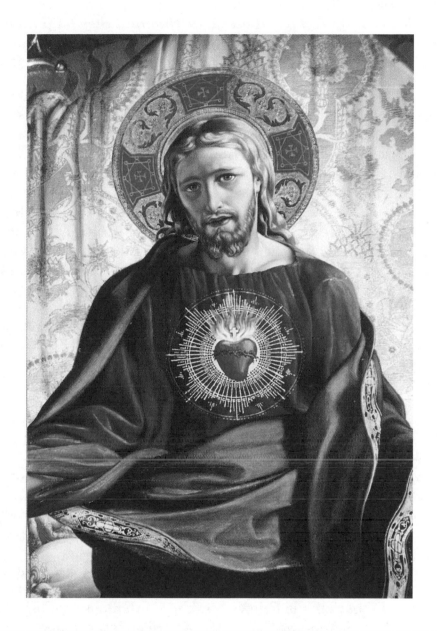

DEDICATED TO THE SACRED HEART OF JESUS

About the Cover

IN THE VILLAGES THE SICK WERE BROUGHT UNTO HIM

And whithersoever He entered, into towns or into villages or cities, they laid the sick in the streets, and besought Him that they might touch but the hem of His garment: and as many as touched Him were made whole.

(St. Mark 6:56)

This painting, a scene out of St. Mark's Gospel, shows the many suffering people who came to Jesus seeking to be healed. Notice the poor, crippled man before Our Lord. What an effort it must have been for the lame man to climb the steep stone steps with only a primitive type of crutch to assist him up the unevenly hewn surface. Study the faces in the crowd. Look at the worried mothers bringing their sick infants to Jesus. There is the man on the left, arms lifted up high. Is he pleading for a cure? Or perhaps he is shouting praises of recognition to the Messiah, Who stands before him. Can you detect the sadness in the faces of the crowd? We do not see any physical infirmities in most of them, but their faces tell us it is their souls that need the Heavenly Physician's cure. Who is the bearded man directly behind Jesus Christ at the left side of the picture? Is it a safe guess to assume he is an Apostle?

Note the architecture. The high stone walls in this alley give us a realistic sense of what the buildings of Jerusalem looked like in Our Lord's day. The wooden shutter high above hangs open for the inhabitants to catch a glimpse of Jesus. James Tissot, known for his attention to authentic detail, traveled to the Holy Land three times in order to render his Biblical scenes as accurately as possible.

It is interesting to note that Tissot chose the final passage of a Gospel chapter rich in events. The chapter opens with the incredulous neighbors who reject Christ's teachings, and cause Him to proclaim, *A prophet is not without honor, but in his own country*. Next, Christ calls the twelve Apostles and gives them command over unclean spirits, sending them out two by two. In the same chapter, we read the account of Herod's beheading of St. John the Baptist, the Precursor of Our Lord.

Jesus mourns the loss of St. John the Baptist and goes out to the multitudes. He has compassion on them because they are *sheep not having a shepherd and He began to teach them many things*. This is followed by the miraculous feeding of the thousands with only five small loaves and two fishes, the entire substance of a young boy's lunch. The scene which immediately precedes Tissot's rendition of the final chapter passage is Jesus walking upon the water.

As we study the painting, let us be mindful of all that the sixth chapter of St. Mark contains. As we look at Jesus, we can see His Face is a mixture of sadness and pity. His Sacred Heart is heavy as He bears the rejections from His own. Yet, His loving Heart is moved to reach out tenderly to all the other outcasts, especially those who have become so as they seek to follow Him.

Contents

London Visitors (c. 1874)

Preface

The paintings in this book are by the celebrated Victorian artist James Tissot. They have been taken from two monumental works: *The Old Testament* (two volumes) and *The Life of Our Lord Jesus Christ* (two volumes), which the artist undertook after experiencing a religious conversion.

Tissot died at the beginning of the 20th century; however, the words used in this book to describe the paintings from his series on the life of Christ are his own words. In editing this section of the book, we have not changed his words, except to update 19th century spelling. Some of Tissot's words were edited for the purpose of space. Nothing has been added to the comments that Tissot made in describing his religious paintings. Rather, any changes in the descriptions provided by Tissot have been deletions of text.

The commentary on the Old Testament paintings has been done by Fr. Constantine Belisarius. He has brought together history, art, and theology in his analysis of Tissot's work from the Old Testament. Tissot's Old Testament paintings were painted to appear in a late 19th edition of the Bible. Sadly, he died before he was able to complete the entire set of these paintings, and many were finished by his assistants. In addition to his religious paintings, we have included selections of Tissot's secular work from the height of his success. This is to give the student a further appreciation of the artist's skill, especially his amazing attention to detail. The reader is certain to recognize some of his popular work.

A few words are necessary to explain the choice of paintings that have been included in *Art 7 for Young Catholics*. The criterion for selecting pictures was simple: only pictures in color would appear in this book, but this limited our choices somewhat. Certain events in the life of Christ, which are well-known and would seem to be natural choices for paintings, were not painted in color. "The Presentation in the Temple" is one such painting. Clearly, it is a landmark event in the life of Christ; however, Tissot rendered that moment as a black and white sketch, not a full color painting. Many of the more significant illustrations of events in the life of Christ are omitted for that reason: Tissot simply did not work them as color paintings. The same holds true for his Old Testament paintings. Many dramatic Old Testament moments were not *paintings* but sketches. Interestingly, some of the paintings that he did paint in color and are still in existence appear in black and white in the printed books. Why this is we will likely never know.

The one exception to this criterion is the black-and-white plate of "La Femme Qui Chante dan l'Eglise," ("The Young Lady Singing in Church"), found in the Introduction. We have not been able to locate a color version of this painting; however, its inclusion is crucial to this book, since it was while painting this picture that Tissot experienced his conversion back to Catholicism.

We hope that the pictures and the narratives in this book bring the familiar scenes in the life of Our Lord and in the Old Testament to a new richness of realism both to the student and casual reader, as well as an appreciation for the artist who attempted to bring others to Christ.

Introduction

The book that you hold in your hands is truly a "pearl of great price." It is taken from a collection of paintings that James J. Tissot (pronounced "tee-SOE") created for an illustrated copy of *The Life of Our Lord Jesus Christ*. All told, Tissot created three hundred and sixty-five compositions from the Four Gospels, with accompanying notes and explanatory drawings.

In his book, Tissot remarks that he had read the Gospels "over and over again a hundred times" in order to gain a clear and accurate picture of the Biblical scenes. He studied the writings of the Jewish historian Josephus as well as many of the ancient historian's contemporaries. In addition, the writings of the mystic Anne Catherine Emmerich, who was beatified by Pope John Paul II, were consulted by Tissot for his compositions. Tissot also made three trips to the Holy Land in order to ensure the authenticity of his paintings.

Besides the works taken from *The Life of Our Lord Jesus Christ,* we have also presented several paintings from the period prior to Tissot's conversion, as well as paintings he made for a similar work on the Old Testament on which he was still engaged at the abbey in Bouillon, France, when he died.

About the Artist

The artist James Tissot (1836-1902) was born Jacques (James) Joseph Tissot in Nantes, France. Tissot is known primarily for his charming illustrations of Victorian life in England, his adopted home. While a caricaturist for *Vanity Fair* magazine, he became friends with London's social elite and soon became a successful and much sought-after portrait painter, especially of the elegantly dressed beautiful women in London's wealthy circles. The Russian Czar Alexander II was numbered among Tissot's illustrious clients.

Although Tissot was raised in a devoutly Catholic home, he fell away from the Faith and was not living a moral life during the height of his success and popularity. However, while working on his series of fifteen paintings, *La Femme à Paris* ("A Woman of Paris"), entitled in English *Pictures of Parisian Life,* Tissot had a religious experience. His work on a

painting that contrasted a beautifully dressed lady of high-society standing alongside a simple nun in a choir loft as they were attending Mass required Tissot to visit a church for sketches of its interior. The artist, who had hardly been inside a church for many years, suddenly had a vision of Jesus comforting the poor. This experience converted Tissot from the worldly, sinful man he had been to a man determined to use his God-given talents to bring others to Christ.

After his vision, Tissot devoted the remaining sixteen years of his life to Biblical paintings. It is told that Tissot destroyed one of his newly completed religious compositions when a woman called it a "masterpiece." On his third attempt at the composition, that same woman dropped to her knees to pray before the picture. Only then was Tissot satisfied with his work.

His lavishly illustrated *The Life of Our Lord Jesus Christ*, from which the greater part of this book is derived, was his labor of love for the next ten years. Tissot followed this project with an illustrated Old Testament, which took up the last six years of his life.

Tissot's studies of Sacred Scripture and ancient history, his visits to the Holy Land, and his precise attention to detail in depicting the peoples of the time of Christ enabled Tissot to convey a realism in his Biblical illustrations on a scale never before attempted. They are best described as a "witness to the truth." He gave his characters a convincing quality that even a "doubting Thomas" could believe. His hope was to correct the misconceptions planted in the minds of the faithful from the typical Renaissance artists of religious artwork. Tissot attempted to convey a more accurate rendition of Christ's life, the scenery of the Holy Land, and its people, while at the same time inspiring the viewer with a love and appreciation for what our Savior had done for us all.

Tissot painstakingly researched the customs and dress of Biblical times. He visited the Holy Land locations where the events depicted in his illustrations had taken place and brought back hundreds of sketches, notes, and photographs. Tissot sought to set the record straight on the images of the life of Christ. For example, Christ's crown of thorns is traditionally depicted by artists as a narrow woven crown surrounding Our Lord's Head. In actuality, it took the form of a helmet that completely covered His Sacred Head, piercing it in many ways and places. Tissot's depiction of Christ's Passion and death on the Cross uses the image of the helmet.

Tissot described his Biblical renditions "as prayer" rather than work. Indeed, his drawings seem to be inspired. Tissot stated that while he was drawing the face of Our Lord, his own image would blur, and another image would appear miraculously for him to trace.

Many of Tissot's Biblical paintings can be seen at the Brooklyn Museum in New York, such as this watercolor composition, which served as the frontispiece to *The Life of Our Lord Jesus Christ*. The artist combines several symbols rich in traditional Catholic teaching. Our Lord stands, barely visible, behind the latticework on the right, which alludes to the Canticle of Canticles: "Behold He standeth behind our wall, looking through the windows, looking through the lattices." (Canticle of Canticles 2:9) The large sunflowers represent the soul's need to follow Christ, as the flower needs the sun. To the right trails a grapevine, representing the Sacrament of the Holy Eucharist.

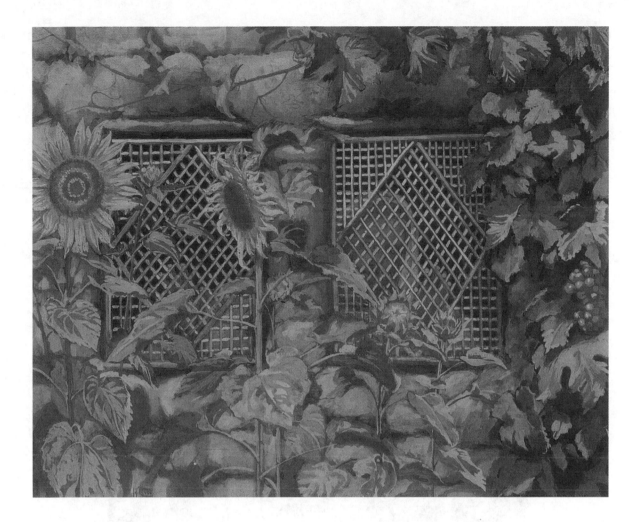

What is the painting's message? According to Nancy Rose Marshall and Malcolm Warner of the American Federation of Arts and the Yale Center for British Art, who are the authors of *James Tissot: Victorian Life/Modern Love* (Princeton, NJ, Yale University Press, 1999), "The message of this simple and delicate watercolor is that through the rituals of the *true Church* the worthy soul may find Christ" (emphasis ours). This is hardly a statement one would expect from a secular source!

Tissot's paintings on the life of our Savior had a profound effect on the public. According to one biographer, women on both sides of the Atlantic attending his exhibition on the Life of Christ would get down on their knees and move in this position from picture to picture, "as though in adoration" of Our Lord Jesus Christ.

It is our hope that both the student and the parent-teacher will experience a similar effect as they view the almost tangible yet mystical realism in Tissot's paintings and read the artist's actual words of his experiences, noticing how he earnestly attempted to bring the words of Sacred Scripture to life.

This is a painting called "Portrait of the Pilgrim." Tissot placed this self-portrait on the final page of his New Testament work. In the accompanying text, he asks his readers to pray for him. "Ye who have read these volumes written for your benefit and have perhaps been moved by what they contain, as ye close them, say this prayer for their author: 'Oh God, have mercy on the soul of him who wrote this book, cause Thy light to shine upon him and grant to him eternal rest. Amen.'"

Tissot signed this request with a drawing of a scallop shell, a traditional symbol for the pilgrim, symbolizing his quest for religious and artistic truth as well as his actual travels to Palestine.

Tissot's Victorian Paintings
The Gallery of H.M.S. Calcutta

The whole painting accentuates the quality of graceful curves. Note the rounded woodwork curving above the windows. The roof of the gallery continues the curve. The scrollwork of the railing is curved, and even the chairs follow the gracefully curved lines, all serving to unite the composition.

The realistic style of Tissot's work is everywhere in the scene. One can easily tell that the roof over the gallery is wood and the rails are iron. Notice, too, the silhouette of the couple behind the glass. Tissot's attention to detail is seen in the cane backs and seats of the chairs. Notice how the yellow bow shows through the caning. Careful attention to the ruffles, bows, and fabric detailing of the ladies' dresses gives them an almost photographic quality.

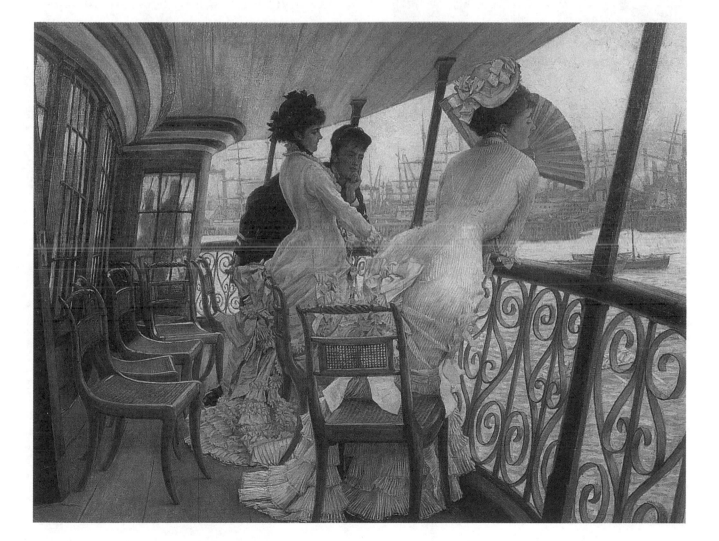

THE FAREWELL

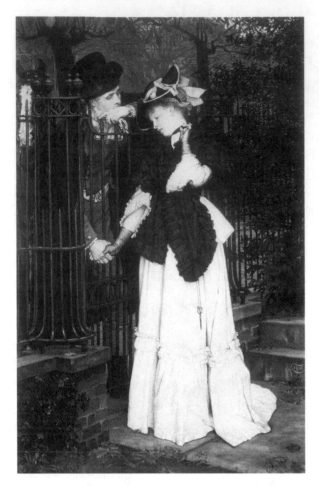

Although Tissot generally painted contemporary scenes of the Victorian era, the subjects in this picture wear the clothing of the eighteenth century. As the title suggests, the couple is saying goodbye. The iron picket fence emphasizes the separation and finality for the sad couple. The gentleman's hand resting on the sharp points of the picket stresses the pain of their farewell. Even the lady's costume provides a clue. From her waist hangs a *chatelaine,* an accessory that was very popular with women of the eighteenth and nineteenth centuries. A chatelaine was made of ribbon, cord, or chain and was used to hold items to keep handy, such as a magnifying glass, key, or as in this case, a pair of scissors. The scissors are symbolic of "cutting" off the relationship. The autumn scene and dark colors add to the melancholy atmosphere.

The costumes worn by the couple provide further clues for their parting. The young man's apparel is that of a wealthy person. The young lady has on the garment of one who belongs to the working class; perhaps she is a servant. It was very difficult in that era for couples from different social classes to marry.

THE BRIDESMAID

The subject of this painting, the bridesmaid, is perfectly centered on the canvas. The artist deliberately does so in order to make her the "center" of our attention. Not only do we, the outside viewers, have our eyes fixed on her, but she has also captured the admiring attention of many of the passers-by on the busy street. As we study the scene, we notice her brilliant blue dress and how it stands out from the blackness of the groomsman's attire, his protective umbrella, and the coach she is about to board. On the left, the balance is maintained with the black dresses of the two women who might be shopkeepers or possibly governesses or maids employed by wealthy Parisian families. The laborer, also in dark clothing and in the forefront of the painting, appears to be a printer carrying plates of type. He also stops to look and even shouts something at the couple. This we can see by his left hand cupping the side of his mouth. What he may be saying is anyone's guess. Perhaps he sees an opportunity to sell his wares to the well-to-do couple.

On the left is a baker clothed in white with a basket balanced on his head. He, too, has his eyes fixed on the lady in blue. Notice the large red spectacles to the immediate left of the umbrella. The spectacles, a store sign hanging above an eyeglass shop, also emphasize that "all eyes" are on the lady of honor.

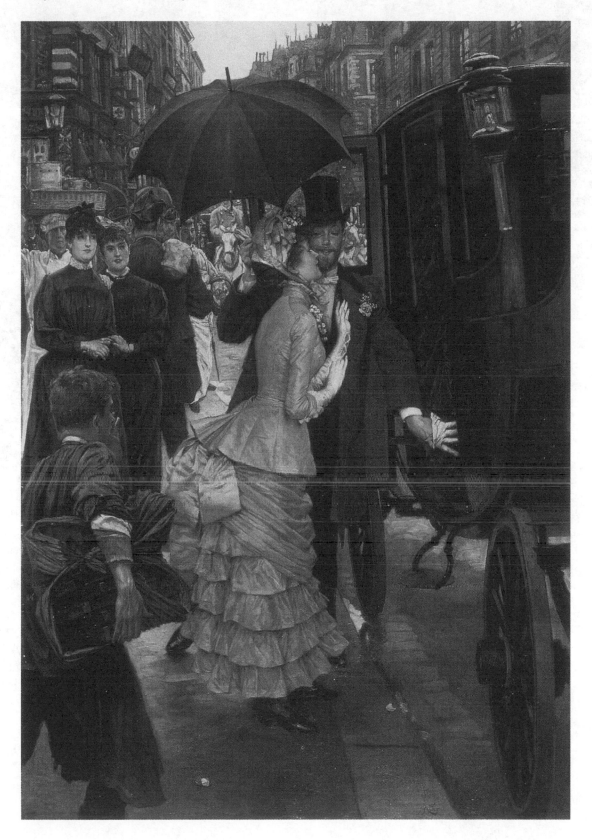

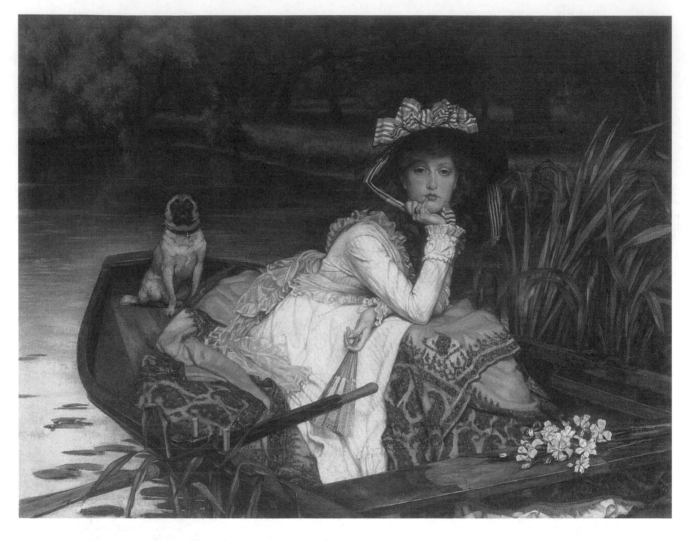

Tissot's art is distinguished for the great attention to detail he worked into his paintings. With all of the effort that went into this detail, one wonders about its purpose. Was it his intent to have any hidden meanings placed in these intricate features? As we study the picture, we notice that the girl, all alone in the rowboat except for her dog, appears to be waiting for someone, but whom? The tiny pug dog seems to think he can be a capable guardian of his mistress. The rowboat has only one oar; how can the young lady row? The flowers on the seat seem to be from an admirer, possibly the one whom she awaits. During the Victorian era, the image of a couple in a boat rowing on a placid lake was a popular symbol for the harmony needed to make a successful marriage. The girl in the boat cannot row with only one oar. The whole scene is symbolic of a young lady waiting for the right young man to come along. Truly a picture is worth a thousand words!

SPRING (OR SEASIDE)

The dress worn by the woman in this portrait is the same one worn in "The Gallery of the H.M.S. Calcutta." If one studies a collection of Tissot's paintings of Victorian England and France, one will see that the same costumes are often found in different scenes. Similarly, a red plaid lap blanket is used as a prop in several of his pictures. The experts believe that Tissot had very definite ideas and tastes and kept certain costumes and props on hand to convey the atmosphere he had in mind. Tissot uses the yellow-beribboned dress to convey the sunny days of the month of July. The yellow pillows continue the sunny theme. Although the forefront of the picture is done in Tissot's style of Realism, the beach scene beyond the window is done in the Impressionistic style of painters such as Monet, Manet, Renoir, van Gogh, or Tissot's good friend, Degas.

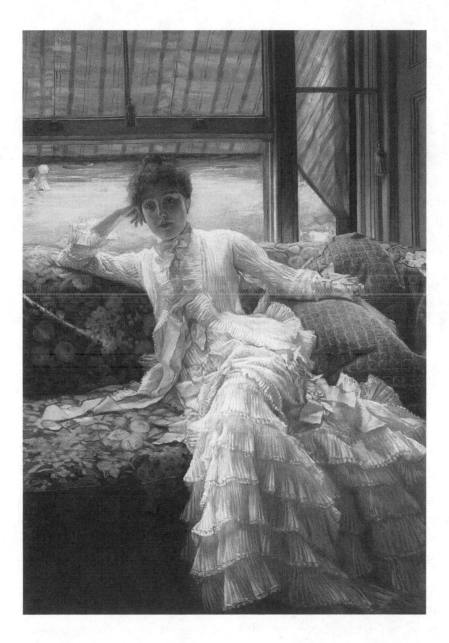

Saint Irenaeus of Lyons was a second-century Greek Father of the Church who was taught by people who had been taught by the Apostle Saint John. He saw the Holy Trinity involved in creation as if the eternal Word and the Holy Spirit were the two hands of God the Father, Who fashioned things out of nothing by the "Word of His Mouth" and "the power of His Holy Spirit." The power of creation is power without any limitation: it is the power to bring something into existence or being out of nothing, nothing at all. God does not merely organize atoms into things; He brings the atoms themselves into being.

Do you see any hands in this beautiful painting of Master Tissot? The clouds cover the ocean deeps and seem to be formed into a thumb on the right hand side, while you can interpret the clouds in the foreground as two hands scooping up the water. Do you see a rabbit in the cone of cloud which is being formed?

*Tissot began work on the series of Old Testament illustrations in 1896 and died in 1902 before completing them. Many of these illustrations were finished by his assistants and therefore have been criticized as lacking the same outstanding quality of Tissot's other works.

LAMECH WITH HIS SON NOAH

Noah is a righteous man from his infancy to his death at a great old age. He is a prophet of word and deed. When all the rest of mankind is wicked, he is obedient, and his obedience saves him and his family. Perhaps he also told the people of the time that the Flood was coming because God was displeased with them. This would make Noah, in a sense, the first prophet, speaking for God to awaken people. However, as in so many cases afterward, the people refuse to believe him. Consequently, they all die. Noah prefigures Our Lord, Who called the Jewish people to enter into the Ark of His Church. Those who did not, perished in the Roman war against Judaea within a generation of forty years.

In this picture, Tissot paints the delight of Lamech in his son. He and his wife rejoice in the birth of a son and heir, but they have no idea of the truly crucial importance of this little boy that Lamech is holding. Indeed, every child carries a universe of promise within himself or herself. It is their choices in life that will realize or frustrate that great promise. Noah will make all of the right choices and will more than justify the joy of his parents for the many years to come.

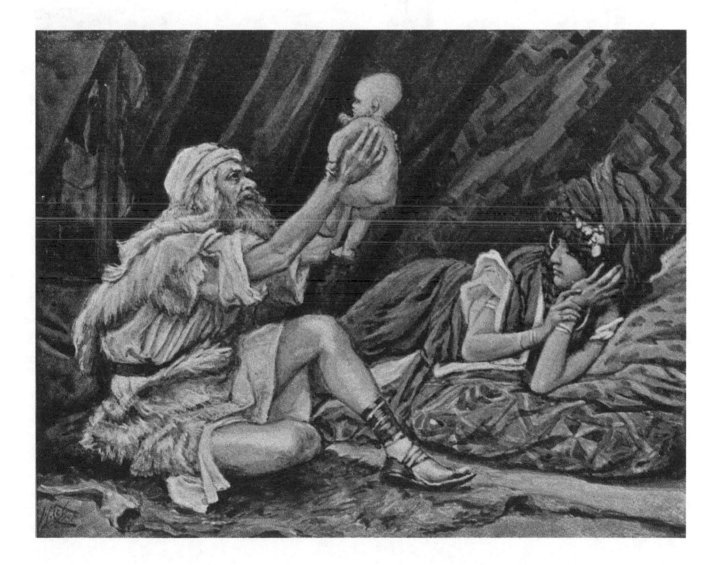

BUILDING OF THE ARK

The scene is of the elderly Noah (Noe) on the left, joined by his three sons, building the ark. The Book of Genesis (6:14) tells us that God directed Noah to build the ark and gave him the exact specifications and dimensions of the huge ship. So large was the ark that it took Noah and his sons one hundred years to complete it.

All the while that Noah and his sons were building the ark, Noah was preaching to his contemporaries about the coming flood. In this he was a prophet of God speaking to the people to obtain their repentance and their safety. They would not listen to him and saw no reason to accept the catastrophe that he predicted. Had the great Deluge not come, Noah would have been classified as a false prophet. However, Noah was a true prophet of God: the Flood came, and all of Noah's contemporaries were drowned; hence, he and his family are the ancestors of everyone living upon the Earth today. Amazingly, modern DNA studies today indicate that all human beings are descended from the same eight individuals: Noah, his wife, their three sons and their wives.

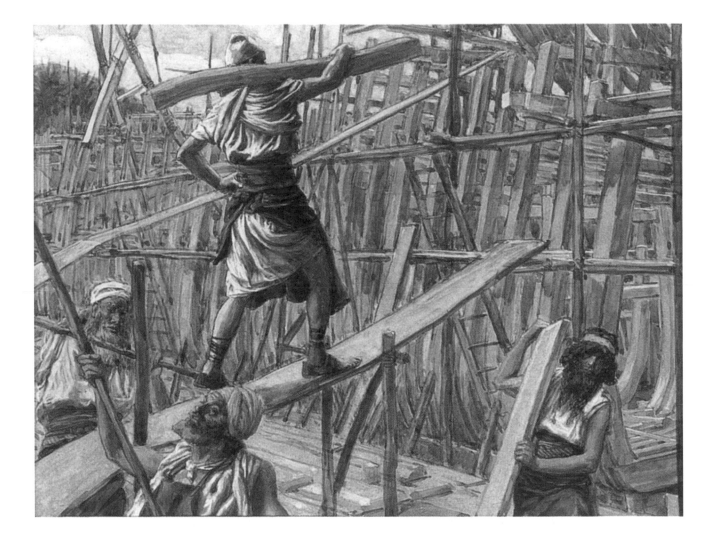

ABRAHAM BLESSES MELCHISEDEK

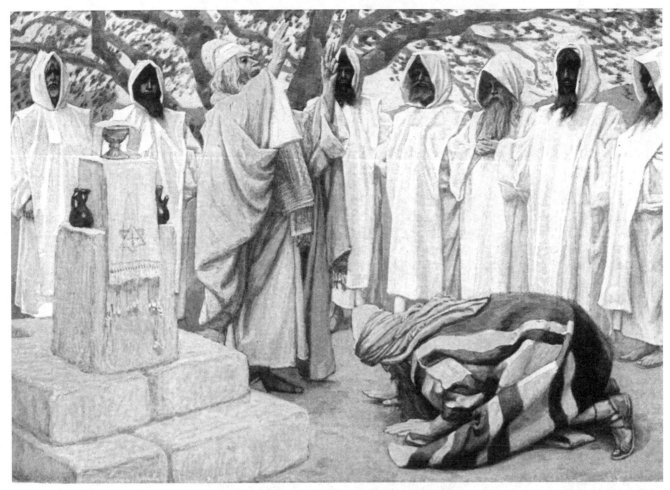

The New Testament Letter to the Hebrews, which is traditionally believed to be written by Saint Paul the Apostle, finds in the figure of Melchisedek a great mystery and a great prophecy: Our Lord Jesus Christ is the High Priest according to the Order of Melchisedek. What is the "Order of Melchisedek"? It is the Order of a priest who is a king, not a king who usurps the office of a priest, like King Saul, who would not wait for the Priest, Samuel the Prophet, but offered the sacrifice of the bulls himself. For this, Saul was rejected by God as an impious king.

Our Lord Jesus Christ is a priest by the fact that He is the Son of God, the eternal Father, and most worthy to offer Him sacrifice. Indeed, He *is* the sole, sufficient Sacrifice. As the descendant of David in His humanity, He has been chosen by the Father to be the heir of David and to make His Kingdom eternal in His own immortality. He is also a descendant of Prince Zerubbabel, the Persian Governor of Israel who built the longest standing Temple to the God of Israel, the Temple erected after the Babylonian Captivity. It was the Temple of Zerubbabel that was expanded and embellished by Herod the Great at the time of Our Lord. The Lord Jesus will never die again. His Kingdom, which is rooted in Him as King, is an eternal, deathless Kingdom.

As Melchisedek was a priest who offered the staples of life, bread and wine, Our Lord turns this bread and wine of Melchisedek into His very own Body and Blood, in the Holy Sacrifice offered on Calvary.

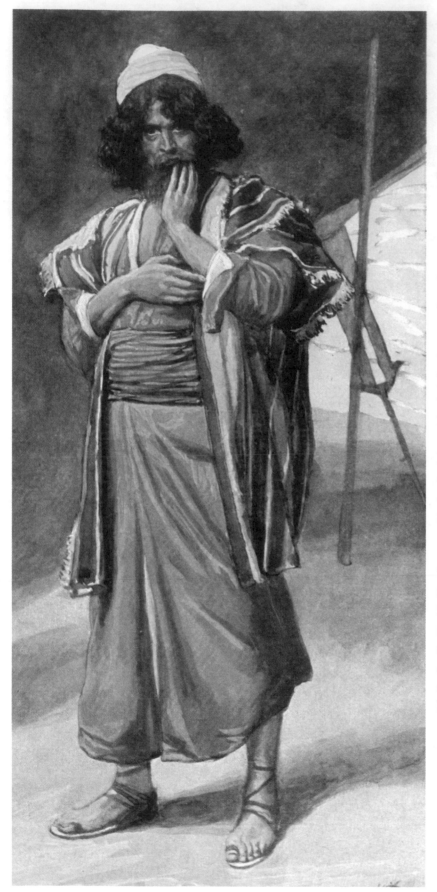

Jacob was the twin of Esau. However, Jacob was the one chosen by God to receive the promise, just as his father Isaac was chosen over his older brother Ishmael before either one of them was born. The child of the Promise was born after the child of expediency, but he was the one to whom God had made and kept His promise.

Esau was a great hunter and the favorite of his father, but God had not chosen him. Jacob was the husband of two sisters, who were his cousins. He had wanted only one, and he loved only her. That was Rachel, the younger of the two sisters. However, Rachel's father, Laban, wanted his older daughter Leah to marry before her younger sister, so he tricked Jacob into marrying Leah. But Jacob loved Rachel and waited for her and finally married her.

Jacob had at least four wives, who gave him twelve sons, but he was not a wise father: his preference for Joseph aroused the jealousy of his older brothers and endangered Joseph's life. However, God had a better plan than they had, both for Joseph and for them.

The Stone of Scone, which is a square stone about the size of a pillow, is supposed to be the stone on which Jacob put his head when he slept in Bethel, the House of God. This stone is a national treasure of Scotland, but it is held in a compartment in the Coronation Throne in Westminster Abbey, in England, that was last used on June 2, 1953, for the coronation of Queen Elizabeth II.

What does the dream of Jacob of the Ladder of God mean? Jacob is the father of the Patriarch Judah, whose mother was Leah, the mother of six of Jacob's sons and the ancestor of Jesse, the father of King David, the ancestor of Our Lord. The Ladder of God is a symbol for Our Lord Jesus Christ. Our Lord mentions to Nathaniel that he will see the angels of God ascending and descending on the Son of Man, another title for Our Lord.

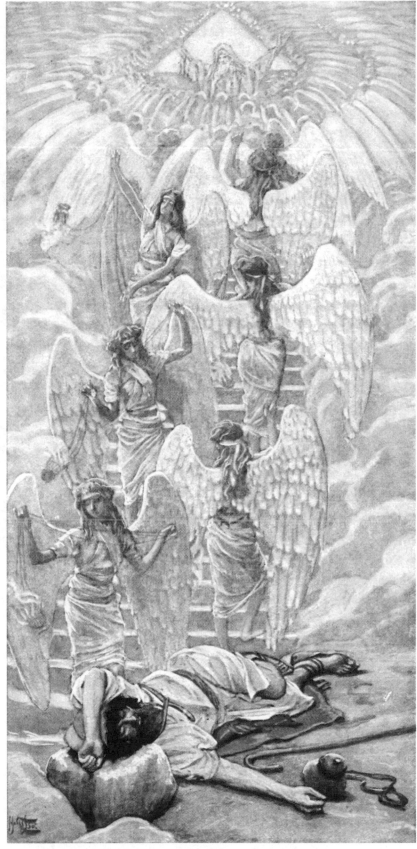

JOSEPH REVEALS HIS DREAM TO HIS BROTHERS

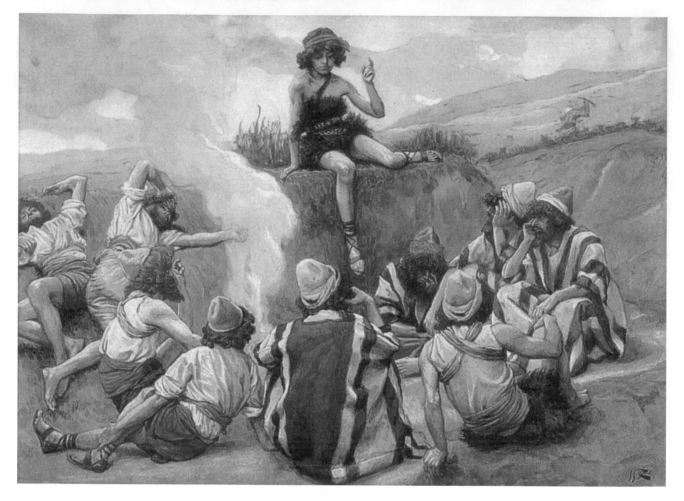

Joseph, the youngest of his brothers, is shown sitting on a rock above them. He speaks with authority, despite his young age. Joseph tells his brothers that in his dream, their sheaves of wheat bowed before his. Joseph is the spoiled, favorite son of Jacob and Rachel, who only gives Jacob two sons before she dies. Benjamin is the youngest of the twelve sons of Jacob, and his mother is also Rachel. Jacob is very unwise in his effusive preference for Joseph. He even gives him a "coat of many colors" to emphasize his place in his father's affections. These signs of favor arouse the envy and hatred of Joseph's brothers, who are young men of no mature judgment. When Joseph recounts his dreams to them, their smoldering jealousy becomes a very dangerous element in the family. Joseph's brothers decide to kill him, but his brother Reuben suggests that they simply throw him into a pit, and they do so. Reuben secretly plans to rescue Joseph later, but while Joseph is in the pit, a caravan of traders came by on their way to Egypt. At Judah's suggestion, the brothers decide (without Reuben) to sell Joseph to the traders as a slave, instead of leaving him to die. Joseph's brothers sell him to the slavers, and they never expect to see him again. God, though, had a better plan, for Joseph and for them.

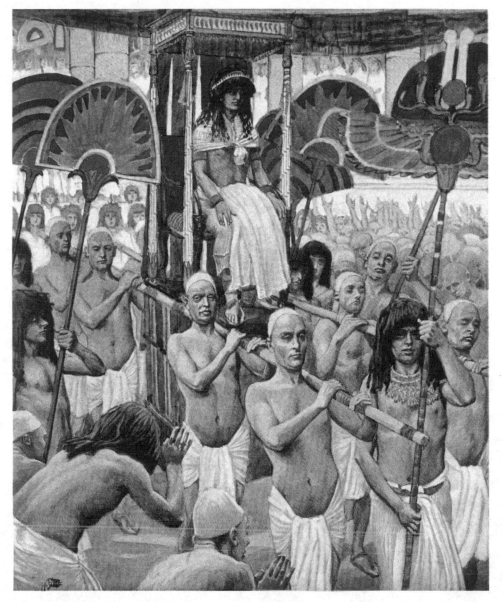

Joseph had been sold into slavery by his own brothers, but the Lord had a plan for Joseph that included his slavery and his arrival in the greatest country of his time: imperial Egypt. Sold into the servitude of an Egyptian army officer, Joseph learned very quickly and was soon managing his master's business. Unfortunately, Joseph's master had a wicked wife, who turned her husband against Joseph, and Joseph was thrown into prison. In prison, Joseph came to the attention of the Egyptian ruler (the Pharaoh) because two of Pharaoh's servants were also imprisoned there. Joseph interpreted a dream of Pharaoh that predicted seven years of plenty and seven years of drought. Joseph was given the power and the authority to prepare for the seven years of drought by storing up the grain of the seven years of plenty.

This picture shows Joseph as Pharaoh's viceroy (acting in the place of Pharaoh, the king). Joseph is dressed in the black wig, the linen garments, and the gold and turquoise jewelry of the viceroy, and is carried on an open sedan chair over the heads of Pharaoh's subjects, with his banner in front and the ornamental fans carried by his higher-placed servants, who are also wearing wigs in the Egyptian fashion.

"MIGHTY PHARAOH"

"Pharaoh" is a title meaning "Lord of the Great House," that is, "Lord of Egypt." Ancient Egyptians mistakenly thought their king was a living god. Though they did not actually think that the Pharaoh created the world and everything in it, they did believe that their king was beloved of the gods, the son of the gods, and chosen by their gods to rule over Egypt, to make her great and prosperous. The Pharaoh was the symbol of Egypt: its temples, monuments, arts and crafts, and way of life, and the aesthetic beauty that can still be seen in the innumerable artifacts that fill the museums of the world.

We do not know the name of the Pharaoh who appointed Joseph as his viceroy, but Tissot has shown us that this Pharaoh is a worthy successor of the dozens of Pharaohs who preceded him. He is surrounded by the banners of his many city-states and the regiments of his renowned armies; he is powerful. The great pillars of his palace hold up a roof which shelters many hundreds of people. They are clothed in linen skirts or kilts that leave their upper bodies uncovered in this very hot, dry country. Pharaoh is dressed in more luxurious fashion but essentially the same. His linen kilt is of a better quality and much longer; his sandals are covered in gold and have a great curlicue at the front. His bare upper body is covered by a gold and fine semiprecious stone necklace. Pharaoh's shaven head is covered by the great war crown, which seems to be modeled on a military helmet. His elevated throne is decorated with golden lions and is set above the heads of his ministers, soldiers, and servants, who raise their arms above their heads and bow down before him.

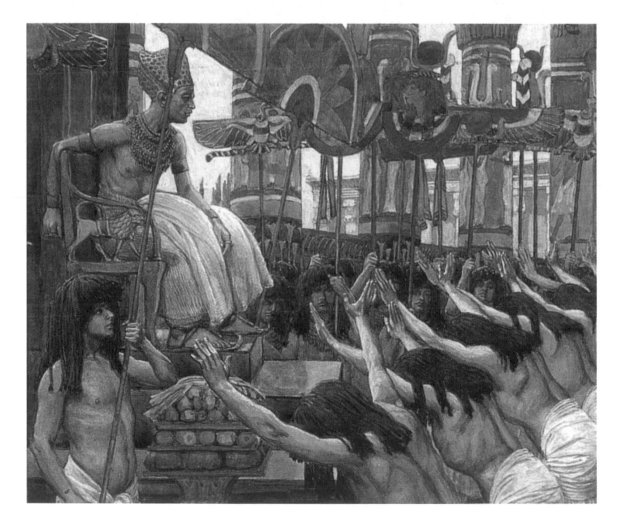

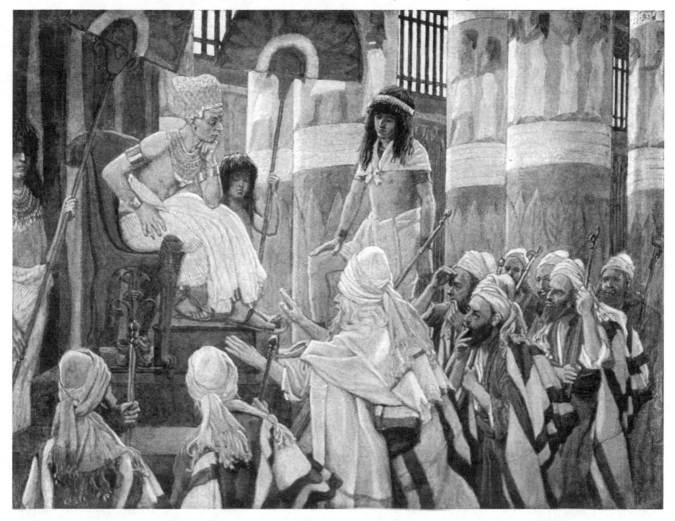

Note how differently the Pharaoh, whose name we do not know, and Joseph are dressed, as opposed to Joseph's father (Jacob) and his brothers, who are being introduced to the most powerful man on the Earth at their time. Jacob and his sons are wearing turbans and the robes of nomads, and they all have a black and white coat that may be something like their tartan – a symbol of their larger family or clan. Is Joseph interpreting for Pharaoh, who seems to be engrossed in the speech of Jacob, whose half profile is visible to us? Pharaoh is wearing the blue and gold war crown of Egypt with the sacred cobra of Egypt as the symbol of his absolute authority in this ancient society. He is seated on his throne on a platform, in a great pillared hall called a peristyle (pillars all around), which is decorated with the Egyptian wall paintings that are so famous today because of archaeology. There are windows with slats, no glass, and the seated Pharaoh is flanked by his fan bearers. He seems to be very interested in Joseph's father.

MOSES AND AARON BEFORE PHARAOH

Another Pharaoh, hundreds of years after Joseph, listens to Moses and Aaron telling him to let the descendants of Jacob, now numbering thousands, to leave Egypt, where they have been enslaved. Moses was saved from the murder ordered by this man's predecessor for all of the boys born to Hebrew or Israelite mothers. How did Aaron escape? We do not know. About Moses, we know that he was discovered in a basket on the Nile, and he was raised as a prince of the imperial house, a son of the daughter of Pharaoh, perhaps one of the Thutmoses whose names remind one of the name Moses. Ancient stories say that Moses was a general for Pharaoh until he himself, in a fit of rage, murdered an Egyptian (probably a nobleman) who was abusing a Hebrew slave. He fled, pursued by the troops of Pharaoh. We see all of these events in the famous film of Cecil B. DeMille, *The Ten Commandments*. Moses outlived those who were seeking him and returned to Egypt at the command of God speaking out of the Burning Bush. Notice that this Pharaoh is dressed exactly like the one who spoke to Jacob, the ancestor of Moses and Aaron: he wears the beautiful blue and gold war crown, his arms have two turquoise bracelets and armbands on each, his upper body is bare while a large necklace covers his chest, and his waist and midriff are covered by a fine white linen or cotton skirt that falls beneath his knees and is belted about the waist with a gold belt. His sandals are curved up, and his lower leg has two more blue bands. For three thousand years, the Pharaohs were dressed like this!

The Pharaoh is sitting on his throne, the legs of which are lions' legs, and the arms are the heads of lions. Moses tells the Pharaoh that Aaron will speak for him because he is a man of slow speech. Moses and Aaron are dressed in flowing robes; they seem to be wearing white monastic scapulars and hoods, which are very early "all weather garments" to cover the head and shoulders from cold and heat.

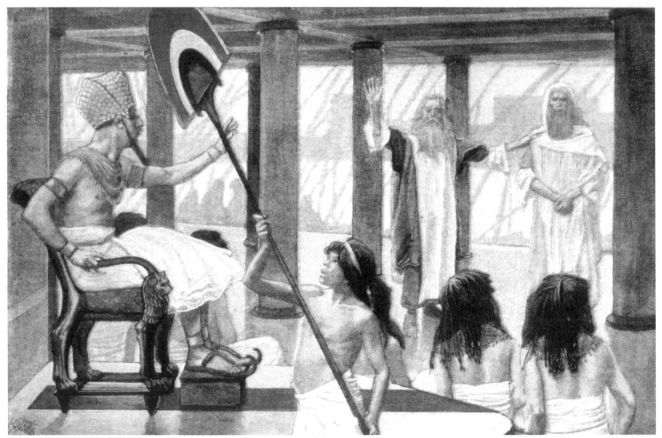

Moses Speaks to Pharaoh

THE NILE TURNED TO BLOOD

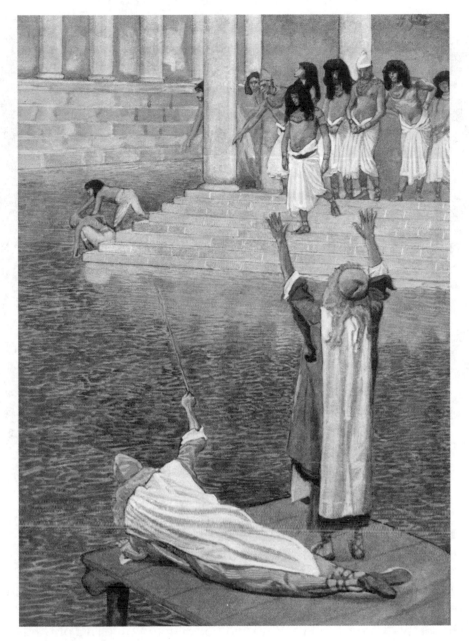

Egypt is the product of the Nile. Without its life-bearing waters, Egypt would be a vast desert. The Nile starts thousands of miles in the interior of sub-Saharan Africa and brings with it the gathered silt of those very fertile lands through which it flows. When Moses caused the Nile to turn to blood (and not just churned up red clay as some unbelievers insist), it was a catastrophe of major proportions for the people of Egypt. Was it the entire length of the Nile? Was it just around the capital of Egypt at the time (probably somewhere between the modern cities of Alexandria and Cairo, in what is called "The Nile Delta")? We do not know. It was enough to frighten Pharaoh.

In our painting, Moses and Aaron stand on the stone jetties that jut out into the river, and the waters have turned red. It was in drinking that the Egyptians realized that the waters had become blood — a symbol or a reminder of the blood of the little Hebrew boys murdered when Moses was an infant.

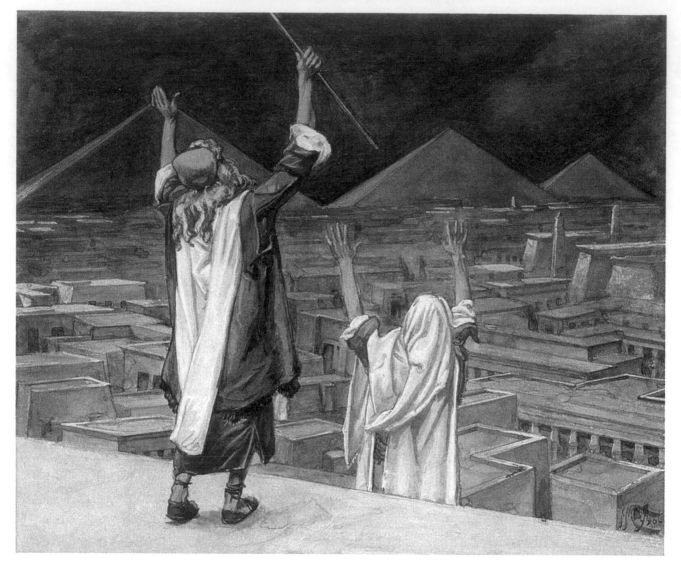

Moses and Aaron are standing on the parapet of a building that seems to be quite near the three great pyramids of Gizeh, the enormous tombs of the Pharaohs Khufu, Khafra, and Menkaure of the early dynasties. The Pharaoh has refused to let all of the Israelites—men, women, and children—along with their flocks and herds, go out to worship. So Moses calls down innumerable locusts, which fill the whole land of Egypt from the coasts to the houses, eating everything left from the hail storms that preceded the locusts.

Tissot shows us what an ancient Egyptian city would look like, with its flat roofs, and its obelisks and temples to many gods stretching out to the horizon where he places the Pyramids. Egypt is great and powerful, but Egypt in the hand of the real God of power and might is like a very small child who has no consciousness of the reality of his situation. God shows Egypt what real power is, the power of the elements, the power of insects and beasts, the power of life and death.

MOSES THE PROPHET AND LAWGIVER
WITH THE GLORY OF THE LORD SHINING FROM HIS FACE

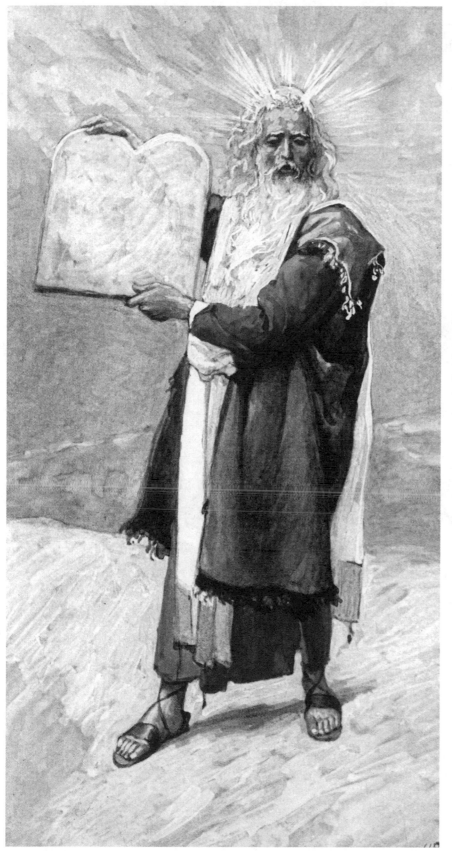

When he came down from Mount Sinai with the Ten Commandments, it was very easy to see that Moses had been with God because the light of God shone out from Moses' face and made it very difficult to look at him; the light blinded people. Therefore, when this light was very bright, Moses would cover his face with a veil so that people could talk with him and work with him.

Moses is a type of Our Lord Jesus Christ, but his greatness only gives us a very faint idea of the reality of the Incarnate Word, Who was probably the One talking with Moses on Mount Sinai.

MOSES POINTS TO THE BRONZE SERPENT

The Lord sent, into the camp of the disobedient Israelites, fiery snakes that bit and killed them in punishment for their disobedience to God through Moses. To show them that He had chosen Moses and made him special, the Lord ordered Moses to make a bronze serpent that looked like the snakes that bit the Israelites and killed them. If they just looked upon the bronze serpent, they were healed of their snake bites. In this bronze serpent, we can see a foreshadowing of the crucifix of Our Lord.

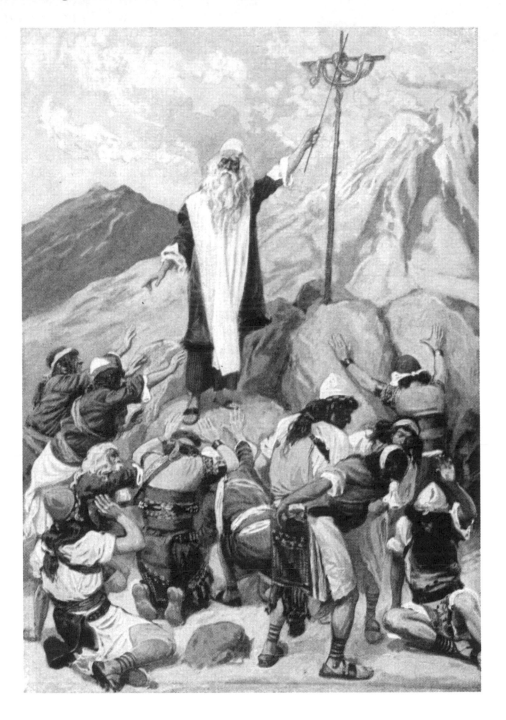

Moses' Arms are Held Up to Ensure the Israelite Victory

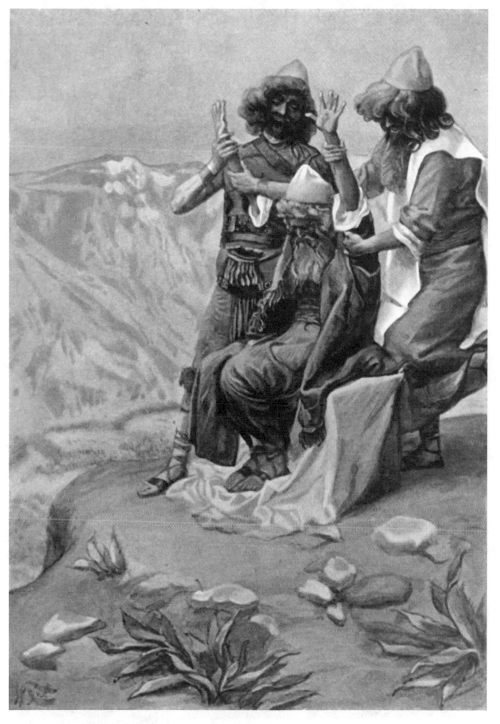

Another way that God chose to show the Israelites how powerful He is and how special Moses was to Him was for Moses to raise his arms in blessing over the Israelite soldiers: while he did that, they were victorious, but when he got tired and put down his arms, the Israelite soldiers were beaten. Then Aaron and Hur held up his arms, and the Israelites achieved final victory.

Have you ever seen the film *Ben-Hur*? The actor, Charlton Heston, played the hero, Prince Judah Ben Hur. Prince Judah Ben-Hur was supposed to be a descendant of this Hur who held up one of the arms of Moses to guarantee the victory of the Israelites.

THE RIGHTEOUS MOSES LOOKS FAR TO THE HOLY LAND

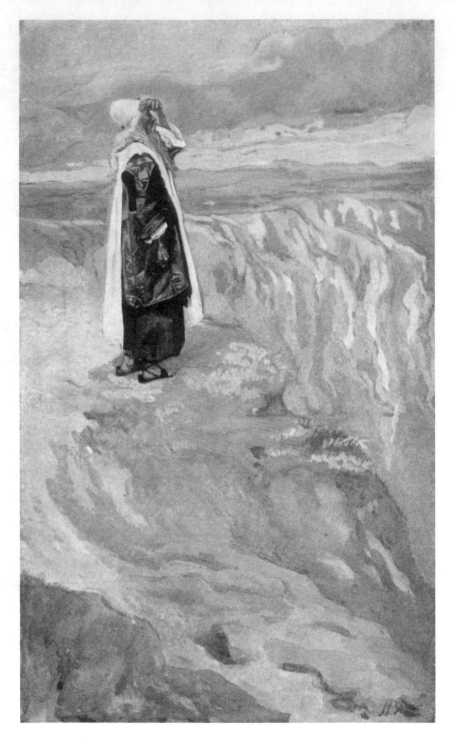

No one may enter into Heaven except saints who are cleansed of all their sins and their faults and become like God. Moses had, at one point, displeased God by his reaction to the complaints of the Israelite people in the desert of Sin when he struck the rock at Marah for water. God told him that he was displeased with him and would not allow him to enter into "The Promised Land."

In this picture, we see Moses in his old age straining to see the Promised Land, which he will not be allowed to enter.

THE ARK OF THE COVENANT
IS CARRIED AROUND THE WALLS OF JERICHO

There was nothing in the carrying of the Ark of the Covenant around Jericho seven times that would trigger a natural catastrophe of the collapse of the great walls of Jericho. God commanded the Israelites to obey Him: He for His part would flatten Jericho in response to their obedience. The Israelites carried the Ark around the great walled city just as the Lord had commanded, then they blew the sacred trumpets as God had commanded, and He caused an earthquake to demolish the previously impregnable walls.

The Ark of the Covenant is the very center of the religion of the Chosen People before the coming of Christ some thousand years later. It is something like a lightning rod for the presence of God. He rests upon the Ark of the Covenant between the wings of the cherubs that we see here in this painting of Tissot. Their wings are like arms that are held out to each other and touching at the tips of the wings to form a sort of throne where the very presence of God rests. This is Tissot's attempt to visualize for us this very mysterious artifact that was constructed according to God's own specifications that He gave Moses on Mount Sinai.

No one in our day has ever seen the Ark of the Covenant, but it is supposed to still be in existence. Investigation has traced it to Ethiopia, whose emperors claimed to be the descendants of King Solomon and the Queen of Sheba. If the Ark is in Ethiopia, it has been there for approximately 2,500 years!

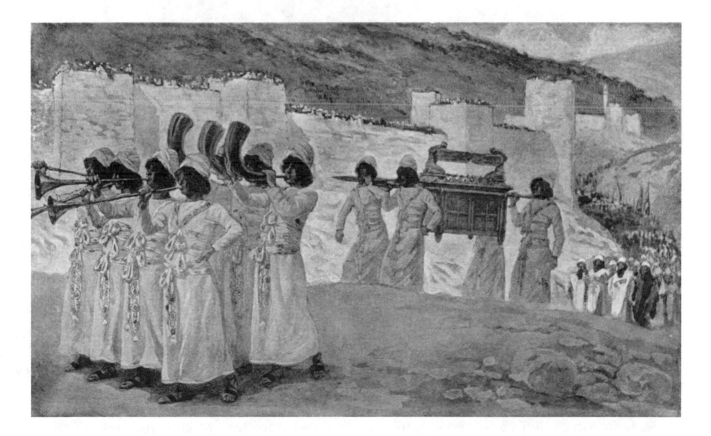

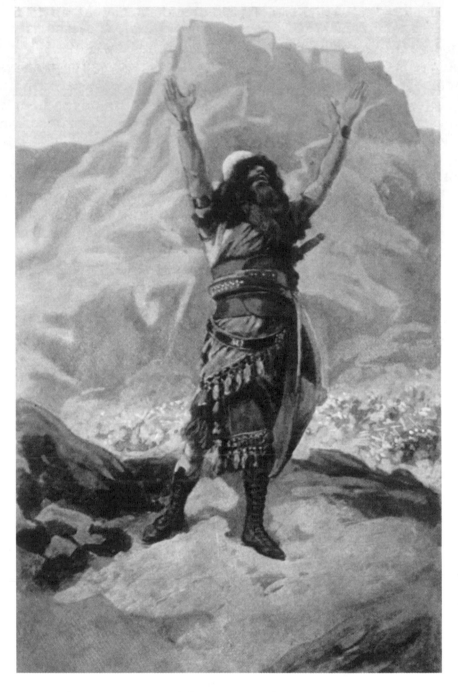

Have you heard of the miracle of Our Lady of Fatima? In 1917 there was a miracle in Portugal at the command of Our Lady, who was appearing to the three holy children, Francisco and Jacinto Marto and their cousin, Lucia dos Santos. This miracle was seen by many thousands of people: it involved a spectacular movement of the sun toward the Earth in a spinning motion. What was probably done by the Lord was making the sun "appear" to move; if it really had moved *physically*, there would have been no Earth left.

Our Lord probably did the same thing with Joshua. Joshua did not want the sun to move; he wanted the light of the sun to make it possible for him to keep fighting. The sun seemed to stay in the sky, and the light lasted long enough for Joshua to claim victory.

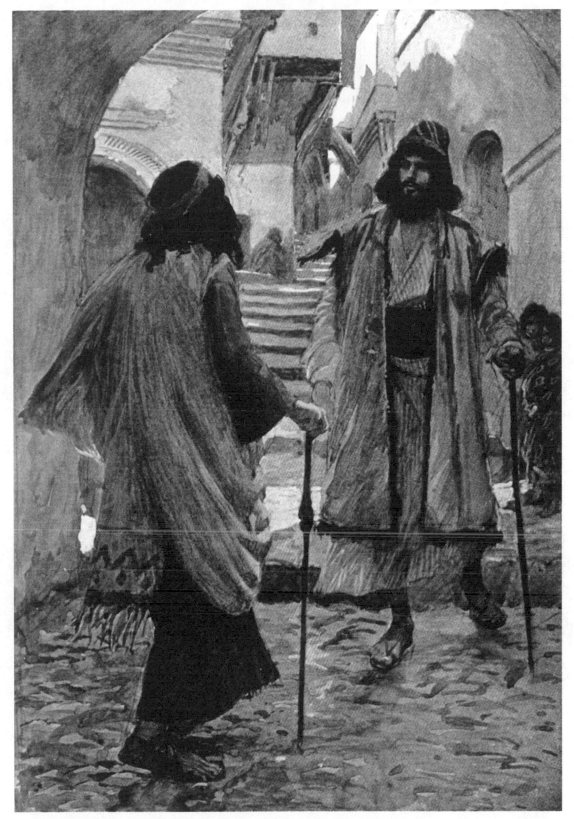

Saul is a religious man. He is found among the prophets who are ecstatically singing and chanting, but he is not a righteous man: he presumes to fulfill the role of priest when Samuel is late for a sacrifice. He does not accept his place in God's plan, but wants to dominate everyone else and do their ministries as well as his own.

SAUL AND THE SACRIFICED BULLS

God rejects him as presumptuous, and King Saul knows it. In our picture, King Saul reminds one of a matador who has just killed two bulls in the arena, not a kingly priest who has sacrificed valuable animals to God. Look at the expressions on the faces of those who are assisting at the sacrifice. It looks as if they too understand that King Saul has done a thing forbidden to him as the King. He has co-opted his spiritual father, Samuel, the Priest and Prophet, and displeased God in front of the Hebrew faithful. The Lord calls Samuel to anoint "a man after my own heart" as the next king – David of Bethlehem, son of Jesse of the House of Judah, a young man who realizes that his gifts and his strength come from God, not himself.

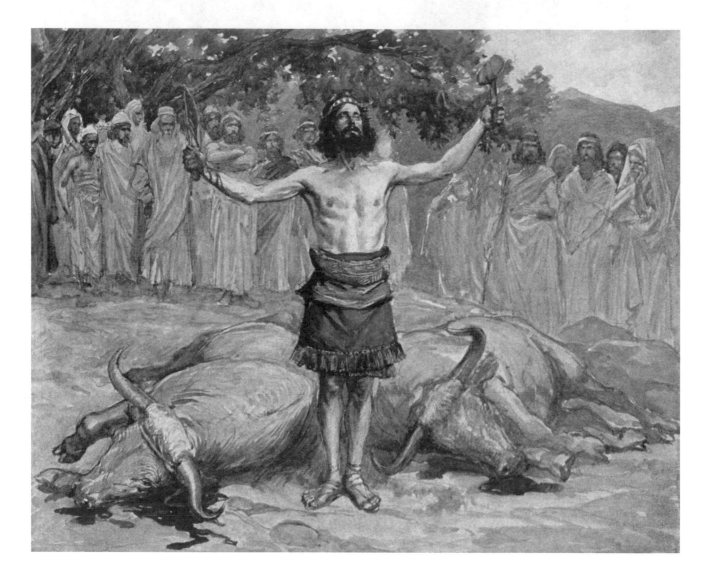

THE ROYAL PROPHET, DAVID, THE SON OF JESSE

David is one of the most important men in the history of the relationship of God with the human race. He is the ancestor of the Christ. "Hosanna to the son of David," the children sang on Palm Sunday. David first appears as a young shepherd who is pasturing his father's sheep while the great prophet and judge of Israel, Samuel, is scrutinizing his older brothers to find the king whom God has told him to anoint with oil to replace Saul, whom God has rejected. "No, not this one! No, not this one! Are these all of your sons?" God has told Samuel to anoint a man who is after His own heart. The moment that the Prophet Samuel sees David, he knows him. He anoints him King of Israel, although David is a very young man.

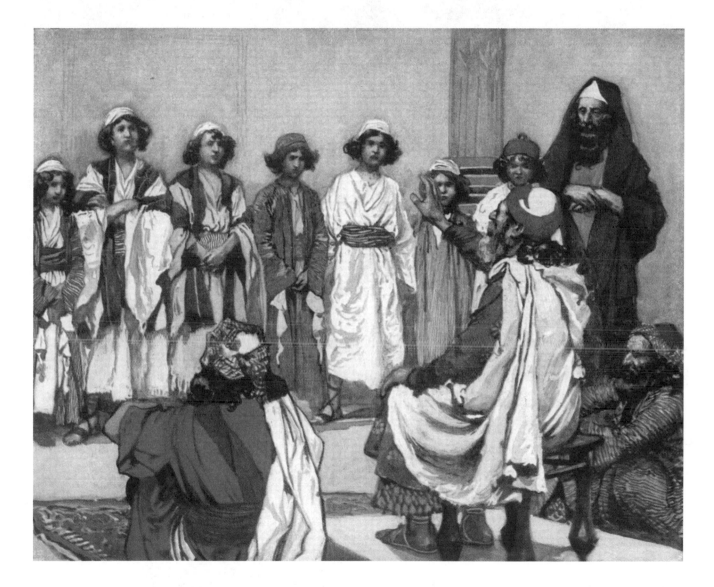

DAVID AND GOLIATH

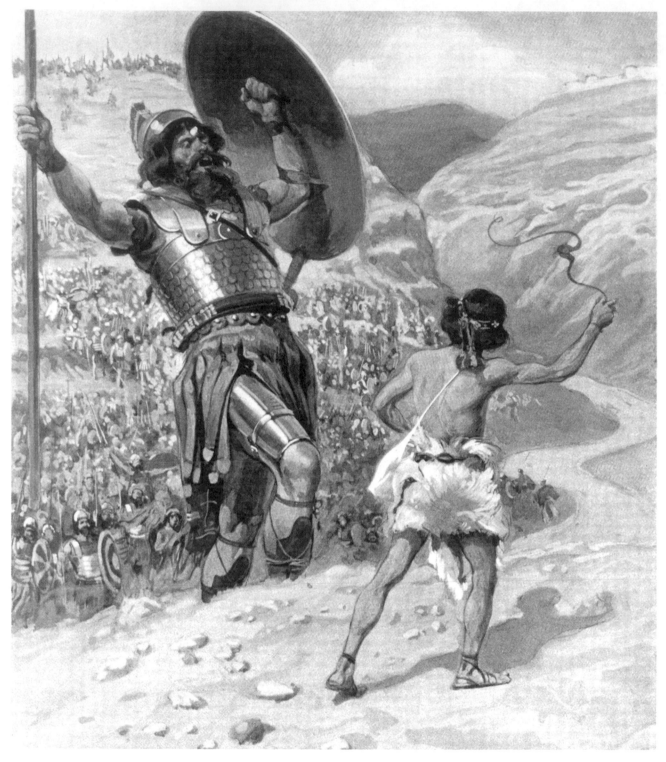

David was a shepherd, not a soldier, but in King Saul's wars his brothers fought while David carried supplies to them from their father. Once, while David was in camp with his brothers, the Philistines sent a seven-foot giant named Goliath against the Israelites. Everything about Goliath was huge: his armor, his weapons, and his pride. The Israelites were terrified of him, and for forty days no one answered his challenge. Finally, David answered. Placing his trust in the Lord, whom Goliath blasphemed, David killed Goliath with a single stone, and he cut off his huge head and carried it back to the Israelite camp.

NATHAN CALLING DAVID TO REPENTANCE

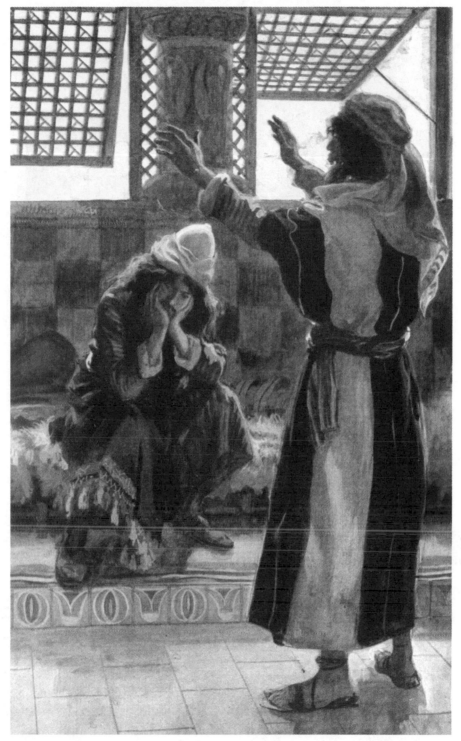

After a complicated history, King Saul and his sons were defeated and killed by the Philistines. David became king. David was a warrior king who united the tribes of Israel and assembled a large kingdom from the disparate elements of the various peoples living in the Holy Land. Although David was a good man who feared God, he was also a sinner, and he once committed a great sin that involved murder. For this, he was rebuked in a parable by the Prophet Nathan. When David heard the parable, he told the prophet that the man at the center of the parable should be put to death. Nathan told him, "That man, O King, is you!" David immediately repented of his sin. That is why God loved him so much. Now, David is a saint in Heaven.

KING SOLOMON DEDICATES THE TEMPLE HE HAS BUILT

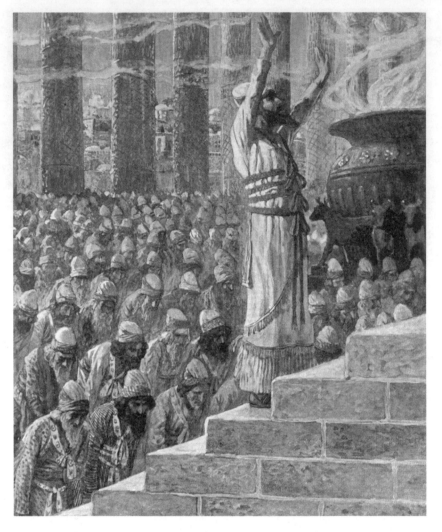

Although his father, King David, was much beloved of God, the Lord did not permit him to build Him a temple in Jerusalem. The task of building the Temple was given to Solomon, David's successor. David not only unified the Kingdom of Israel to give King Solomon a mighty inheritance, but he stockpiled all of the raw materials that he would need to build the Lord a fitting house. Solomon used the most talented and experienced craftsmen and artists to make a magnificent building that would be worthy of the God of Israel.

Tissot does not evoke the reality that we are given to see in the Scriptures: the whole House of the Lord was filled with His glory, which the Jewish people called His "Shekkinah." This is an effulgent light that seems to be filled with gold dust that sometimes is so thick that one cannot see through it. This is what happened when Solomon dedicated the Temple: the whole temple area was filled with such a dense glory of the shekkinah that the priests could not minister there. Here Tissot shows King Solomon on the steps in front of "The Holy Place" where the altar of incense and the table of the Bread of the Twelve Tribes were set. The Holy Place was placed in front of the Holy of Holies, an interior room with no windows that was completely covered in thick gold; in this cube-like room, the Ark of the Covenant was placed. Solomon's arms are raised in praise of the God of Israel as he stands in front of the Veil of the Temple and asks the Lord God to bless the Temple that he has built.

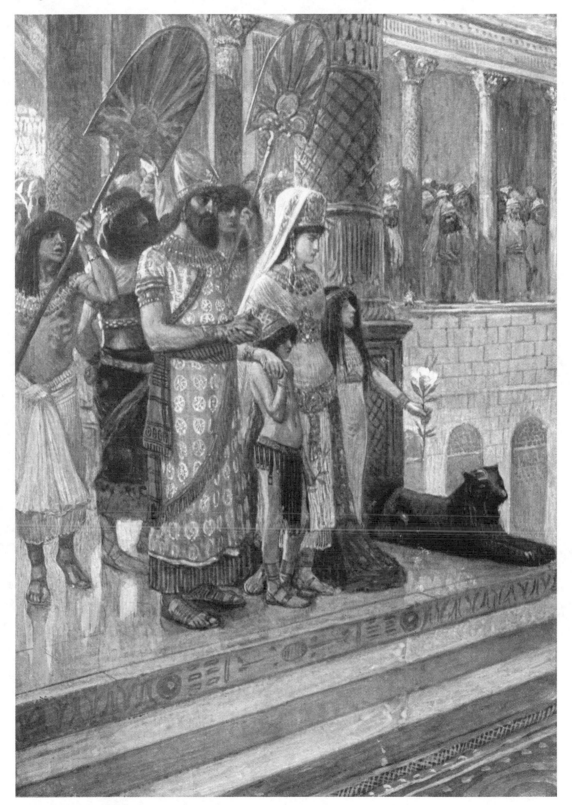

The Queen of Sheba heard that King Solomon was the wisest and the richest of all kings. She came to see for herself, and she was satisfied. She had conversations with him and visited his palace and his capital in Jerusalem. She gave him offerings from her kingdom.

THE PROPHET ELIJAH RUNS IN FRONT OF THE CHARIOT

King Ahab was the husband of Queen Jezebel, who was a fervent worshipper of Baal (a name which means "The Lord," but whose worship and ways were totally opposed to the true God). After the descent of the fire of God upon the sacrifice on Mount Carmel, Elijah ordered the execution of the prophets and priests of Baal who had been trying to destroy the true worship of God in Israel-Samaria. After this, Elijah commanded his servant to go seven times to see if the Lord would bring the three years drought to an end. Then the Prophet Elijah is moved by the Holy Spirit to carry the news of the end of the drought to Jezreel before the king, in his chariot, can reach the city. This can also help us remember that Elijah was carried to Heaven in a chariot pulled by horses of fire. He did not die, and later appeared at the side of our Blessed Lord in His Transfiguration on Mount Tabor. He is the greatest of the prophets, and he appears there with Moses.

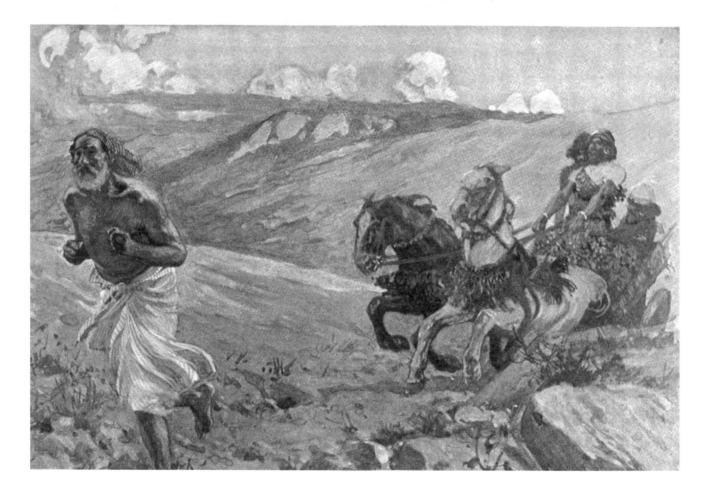

THE THREE-YEAR DROUGHT COMES TO AN END
AT THE WORD OF THE PROPHET ELIJAH

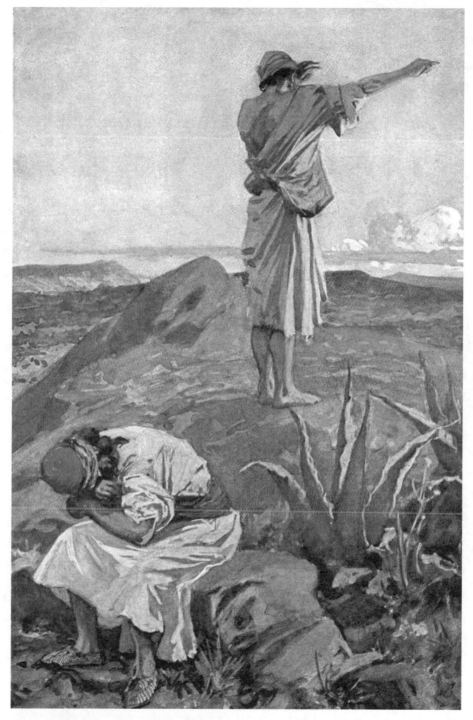

Elijah has ordered the execution of the priests of Baal and now waits for God to crown His triumph with the end of the drought and rainfall. After seven prayers, the Lord causes the drought to end, but Queen Jezebel vows to kill Elijah just as the priests and prophets of Baal have been killed. Elijah will have to flee to Mount Sinai to escape the wrath of the queen, even though the drought has been brought to a close. Elijah will go to Heaven in a fiery chariot, but Jezebel will be killed by being thrown down from the balcony of her palace. This is her punishment for the many murders and other crimes that she urged her husband, King Ahab, to commit against God, His prophets, and His people.

THE PROPHET JONAH

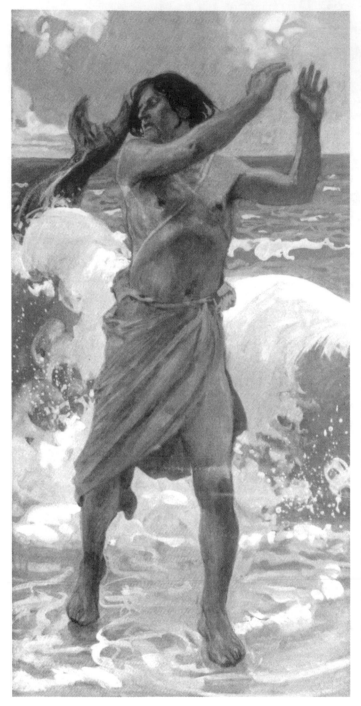

In this picture, we see the Prophet Jonah just as he stands up after having been vomited out of the "Great Fish" that had swallowed him after he was thrown overboard from the ship in which he was seeking to escape to Greece (Tarshish) to avoid giving the saving message of God to Nineveh, the great city of the Assyrians. Tissot does not seem to have known about the man in his own time (1891) who had been swallowed by a whale and lived to tell about it. The man (James Bartley) was a member of a whaling expedition and had somehow fallen overboard and had been swallowed by a whale. He stayed inside the whale as long as it took his shipmates to corner the whale, kill it, and cut it open to save him. This may have been a matter of hours or days. However, a very interesting note is added to the Jonah story by the recorded facts of the famous Ripley's "Believe It or Not." The man who was in the belly of the whale was still alive but was completely bleached by the stomach enzymes of the digesting whale: he was completely white from head to toe! Imagine the fright of the Ninevites when they were confronted by Jonah, if his skin had been completely bleached from head to foot! They would not have found it too difficult to believe his message of death and destruction when he himself looked like a ghost from the netherworld.

THE PROPHET JOEL

It is possible that the three prophets whose portraits by Tissot we are presenting here could have known each other, but we do not know. They have left us written prophecies without too much personal information. They are found in the ranks of "The Twelve Minor Prophets," and the three of them are dated to the time of the return after the "Babylonian Captivity," or "The Exile in Babylon," five hundred years before Our Lord.

The Persian Emperor, King Darius I, decreed that the Israelite exiles were free to return to their country, and he encouraged them to rebuild their Temple and their capital city. The three prophets protest that the Lord God of Hosts is not pleased with the fact that the exiles, the rich, the aristocrats, and bureaucrats have chosen to rebuild their own private homes and to leave the "The House of the Lord" in ruins. Joel's prophecy seems to be a deeper call to rebuild the House of the Lord in the hearts of the people by a return to Him in word and work, in true repentance for the behavior that occasioned the Exile into Babylon.

THE PROPHET ZECHARIAH (ZACHARIAS)

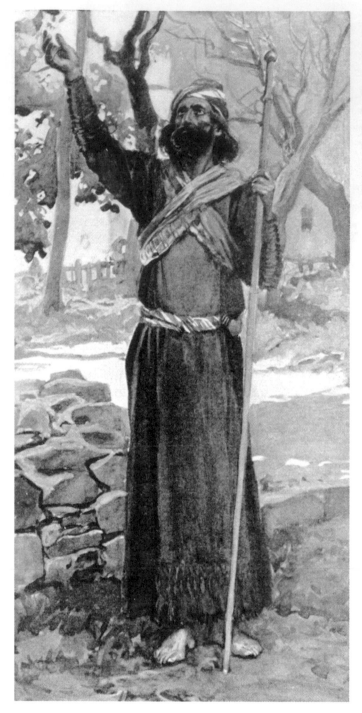

Zechariah was a contemporary of the Prophet Haggai; he is the eleventh of the twelve Minor Prophets and is remarkably Messianic. It is from Zechariah that we have the prophecy of the King of Jerusalem coming to His people riding on the foal of a donkey, the price of the Shepherd being that of thirty pieces of silver that is thrown back into the Temple Treasury, and the people who have rejected Him mourning as for an only child.

THE TRIUMPH OF THE RIGHTEOUS MORDECHAI OVER HAMAN

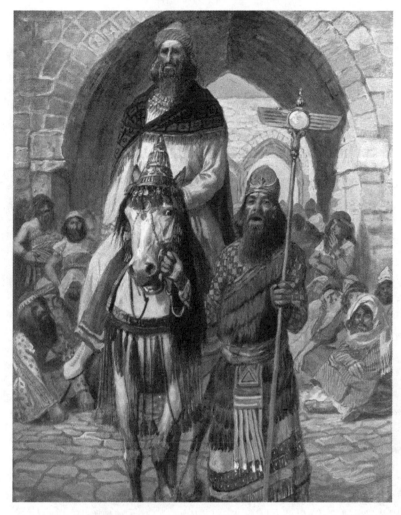

Mordechai represents the righteous man who tries to serve the one, true, and living God in a corrupt society. Mordechai raises an orphaned niece as his own daughter, and she eventually succeeds Queen Vashti as the Queen of Babylon. Her name is Esther, and she has the ear of her husband, King Ahasuerus. Early in the marriage, she tells him of an assassination plot because of information Mordechai has learned. The would-be murderers are caught and executed. Soon after, Ahasuerus's Prime Minister, Haman, decides to kill all the Jews because he hates Mordechai, and Mordechai is a Jew. Meanwhile, Ahasuerus learns that Mordechai, who helped save his life, was never rewarded. The King therefore asks Haman how he should honor a hero. Haman, thinking the King is speaking about him, suggests an elaborate parade through the city to advertise the virtue of the hero. But the hero is Mordechai. Haman is humiliated and plans to hang Mordechai on a high gallows. Just the day before Haman is going to kill the Jews, Esther tells the King of Haman's plot. The king hangs Haman on his own gallows!

In our picture, we see the righteous Mordechai riding a horse covered with beautiful cloths and hung with tassels. Haman is dressed as a Babylonian noble. He has a tunic of patterned squares of blue and gold and is draped about with the tasseled robe of a Babylonian official and wearing a sort of crown-helmet that indicates his high office. His staff is the double winged sun symbol of Babylonian power. The people are gathered at the gate of the city to hear about the virtues of the honored man.

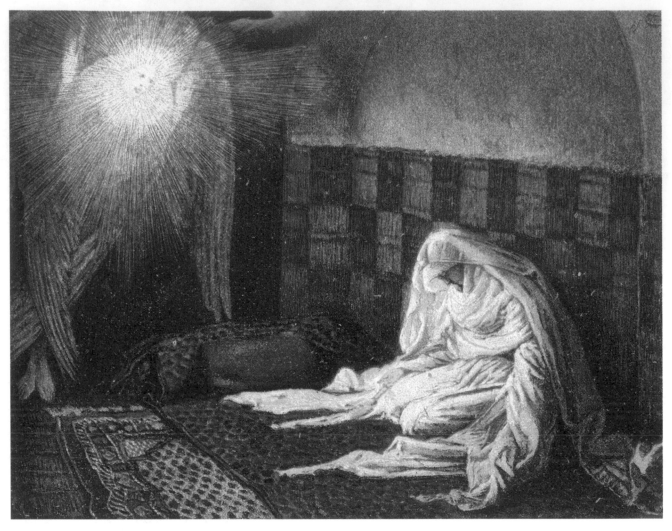

The journey from Nazareth to Ain-Karim, where Elizabeth dwelt, must have taken about four days, the way having been both steep and rough. The hills of Samaria and Judea cut right across the road. The wild valley, known as the Wady-el-Arimaieh, had to be traversed in going from Samaria to Jerusalem. This must have made the journey extremely arduous, especially for the Holy Virgin, in the state in which she was. According to the custom of the country, Mary had to ride on a donkey, Joseph walking beside her. It is natural to suppose that the two travelers, after halting now and again at the caravansaries* by the way, passed the last night at Jerusalem, where Joseph probably had relations. They arrived at Ain-Karim, three hours' journey beyond that town, early on the next day.

Was it at the first interview with Elizabeth that the Virgin uttered the hymn of the Magnificat? Was it not more likely at the time of the private out-pouring of confidences between the two, which must have taken place later on? It seems to us much more natural that it should have been then. We have therefore chosen, as the setting of the scene fraught with such

*a large, bare building surrounded by a court used in Middle-Eastern countries for caravans to rest at night

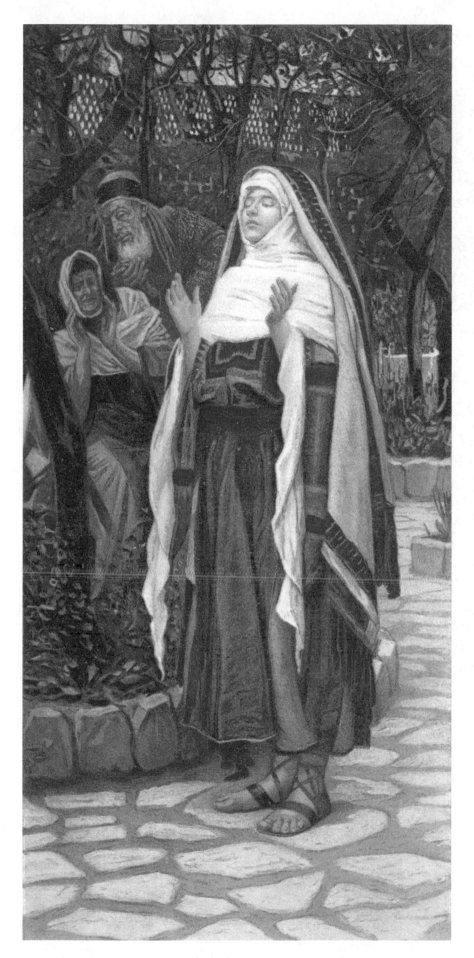

sacred mystery, the secluded garden of Elizabeth. In the midst of an exchange of their strange and wonderful experiences, Mary was suddenly possessed by the Spirit of God. In a kind of prophetic ecstasy, she poured forth her joy at her coming maternity, her humble acceptance of the will of the Almighty, and her inspired insight into the grandeur of the Divine plan. All these various feelings merged in her virgin soul, so pervading her whole personality, that for the moment her own individual life seemed to be suspended. We must not, therefore, look upon the Magnificat as an outburst of loud triumphant joy, but as the quiet, reverent, almost whispered expression of a spirit moved to its very depths. It is a prayer, so intensely earnest as to be scarcely audible, the effect of which was yet further intensified by the dumbness of Zacharias and the emotion of Elizabeth.

The Childhood of Saint John the Baptist

It is three days' walk by the direct road from Nazareth to Bethlehem; and if you go by way of Jerusalem, four days are required.

The travelers summoned to be taxed by the decree of Caesar Augustus must have been very numerous, and the one caravansary the town could boast must have been quite insufficient to accommodate them all. The sort of establishment to which we apply the term "inn" would have been altogether foreign to the Oriental usages of the time under notice and this is still very much the case.

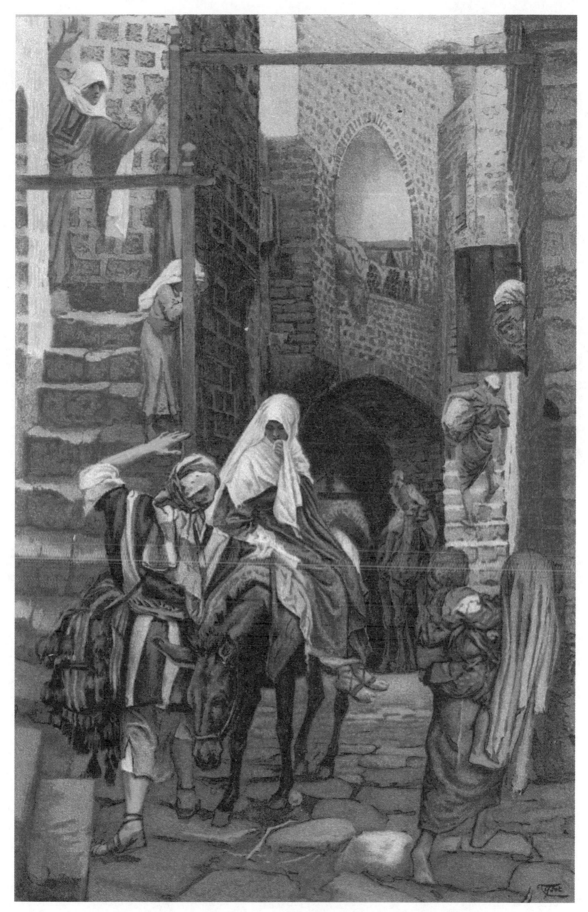

Saint Joseph Seeks a Lodging at Bethlehem

41

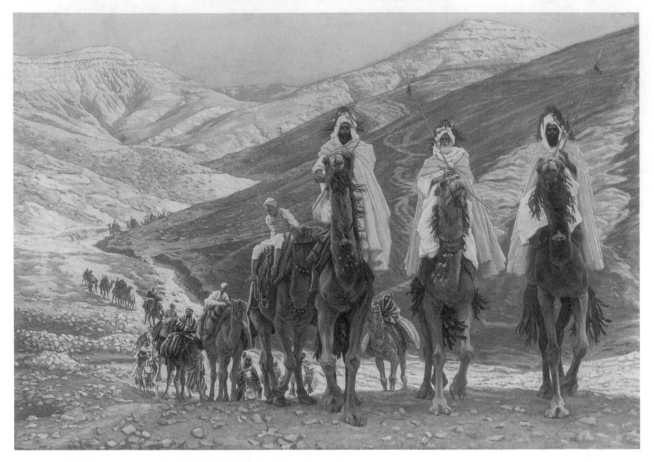

The word "house" used by the Evangelist to indicate the place where the Magi found the Messiah points to the conclusion that, during the journey of their visitors from the east, Joseph and Mary had left the Cave of the Nativity for a more comfortable dwelling. Tradition is against this idea; but it must be remembered that with regard to this event in the life of Jesus traditional accounts vary greatly.

Nothing is certain either as to the number or names of the Magi. According to Saint Leo and Saint Gregory of Arles, they were three in number, thus symbolizing the three persons of the Trinity and the three sons of Noe. The three gifts offered naturally led to this belief. Their names are very variously given, but the names almost unanimously adopted by Oriental tradition are those we meet within the well-known verse of ancient liturgy:

Gaspar fert myrrham, thus Melchior, Balthasar aurum.

Peter of Natalibus makes the three Magi twenty, forty, and sixty years old, respectively. The Venerable Bede goes so far as to describe them. Quoting from a tradition of his day, Bede tells us that Melchior, old and pale, with long white hair and beard, offered gold to the Saviour as King. Gaspar, the second wise man, a beardless youth with a rosy complexion, offered incense as a gift worthy of God. Third, Balthasar by name, shadowed forth by the gift of myrrh the fact that the Son of Man was to suffer death. These types have been generally adopted by the artists of Western Europe.

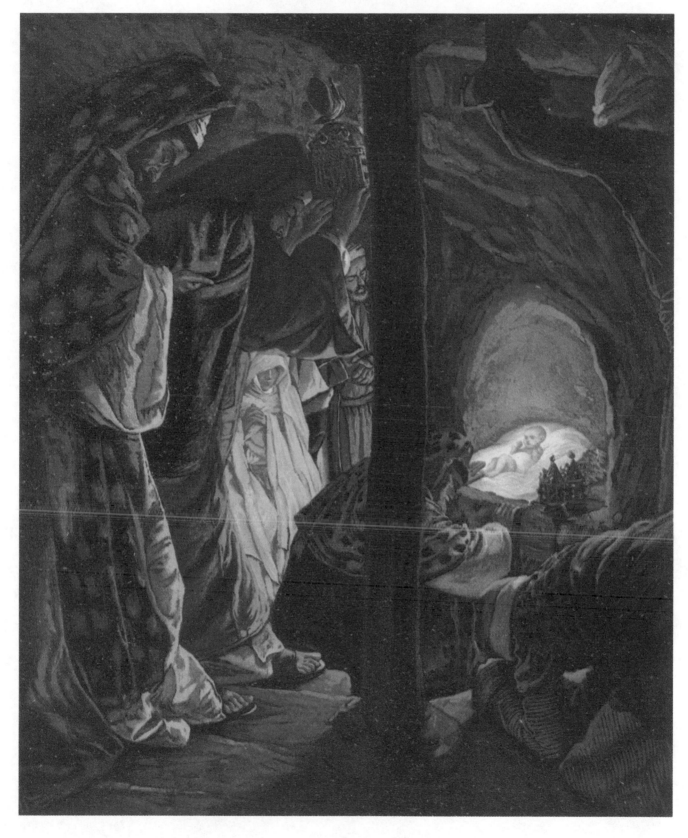

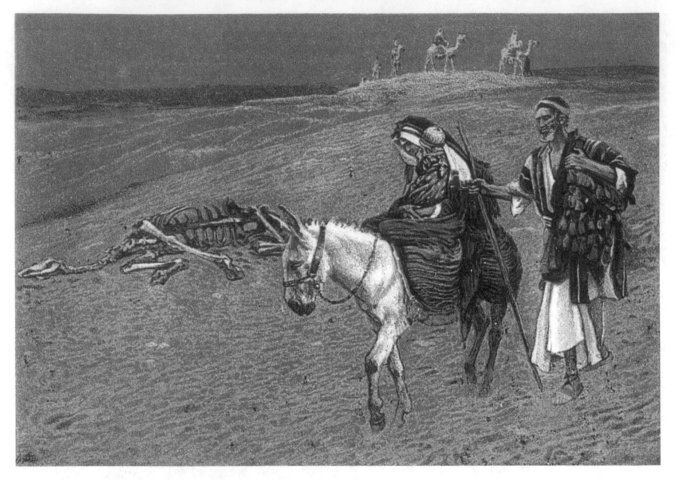

The Women's Court, where the meeting between Jesus and His parents probably took place, was of considerable size and adjoined that of the men. It was reached by a semi-circular staircase on which the Levites, bearing harps, dulcimers, cymbals and other instruments of music, chanted the fifteen Psalms called the Songs of the Degrees. During the offering of sacrifices they chanted near the Altar.

In the background of the picture through the door can be seen the Altar of Burnt Offerings. A red band was painted all round it to indicate where the sprinklings with blood were to cease. These sprinklings, which took place constantly, both within and without the veil upon the Mercy seat and before it, were performed with three fingers, much in the same way as a blow with a rod is given; the blood had to be sprinkled from right to left. The blood was received in a basin of gold with a handle. The bottom of this basin was round, so that there should be no temptation to the Priest to rest it on the ground, for the blood had to be constantly kept moving, lest it should congeal and thus become unfit for the purpose for which it was required. These perpetual sprinklings so stained the veil of the Sanctuary that when Titus took it to Rome it was completely encrusted with dry blood.

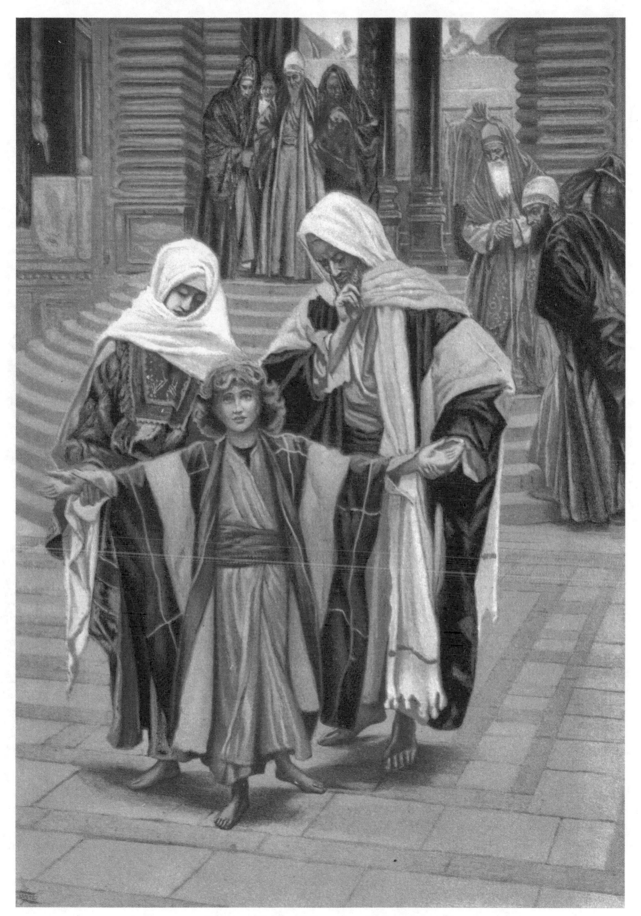

Jesus Found in the Temple

45

THE YOUTH OF JESUS

The Gospels tell us nothing of the occupations of Jesus as a young man. Tradition relates and it appears truly, that He followed the profession of Saint Joseph. Some say that He spent the whole thirty years before He began His ministry in retirement, leading a kind of monastic life devoted entirely to prayer, but nothing could be less probable.

It would have been extraordinary and altogether out of keeping with the spirit of the rest of His life if Jesus had not helped Saint Joseph with his work. Thus He contributed to the support of His family, whose circumstances were humble, and set the example of a useful life to those whom He was later to teach. Saint Paul, even when he became a preacher, continued to practice the craft of a tent-maker, so as not to be a charge to the faithful. It seems only natural that Christ Himself should have done no less than His Apostles, for, to quote His own words, "The Son of Man came not to be ministered unto but to minister."

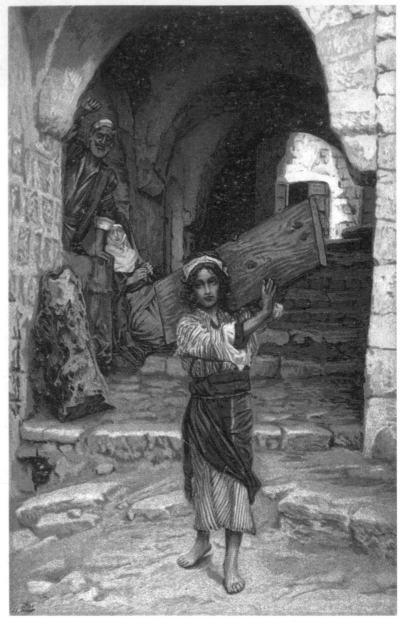

The special idea of the picture called "The Youth of Jesus" is the following: as already stated, Jesus practiced the trade of a carpenter. In the course of His daily work He must sometimes have performed actions foreshadowing certain details of the tragic and bloody drama which was to terminate His earthly career. It is improbable, especially after the prophecy of the aged Simeon, that Joseph and Mary had no inkling of what the future of their Child was to be. With some such inkling in their minds the smallest detail, a mere nothing, would be enough to arouse their anxiety and sadden them. We have imagined some such incident: Jesus is carrying a piece of wood on His shoulder, while Mary and Joseph watch Him thoughtfully with some vague presentiment of the future Cross.

THE BAPTISM OF JESUS

Now once more the Divine Majesty reveals Himself and consecrates the Messiah on the banks of the Jordan. Twice more in the life of the Saviour will a similar manifestation take place: once on Mount Tabor at the Transfiguration and once in the Temple on the Wednesday of Passion week.

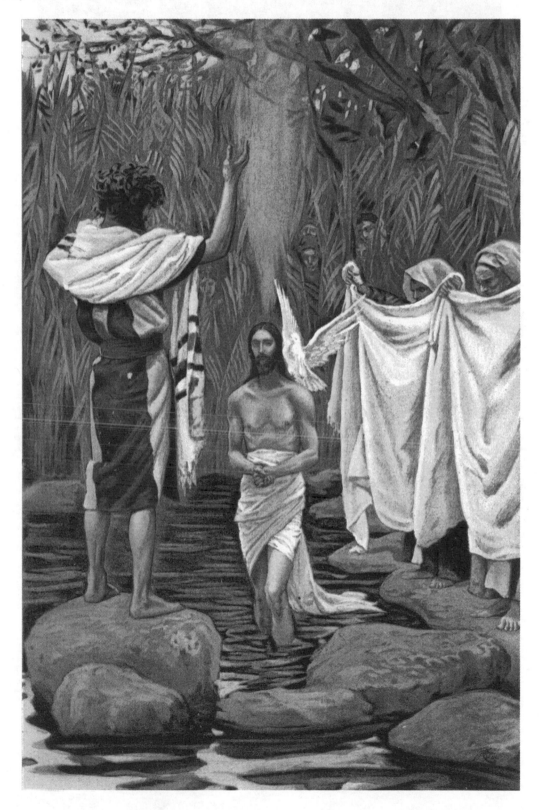

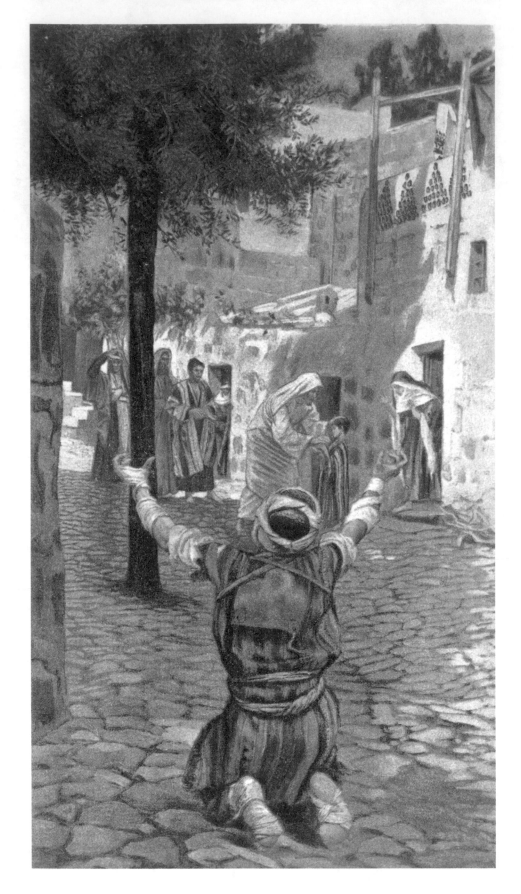

Amongst the Jews there were special laws respecting the lepers. These sufferers were compelled to take certain precautions to protect their fellow men from coming in contact with them. On all ordinary days of the year, lepers had to keep in the middle of the path or road, the undefiled passing by on either side. The rule on feast days was just the reverse. This difference is easily explained by the desirability of leaving as clear a space as possible for circulation and traffic.

The very soil of the city of Jerusalem was considered sacred, and therefore lepers could not enter it until their recovery had been certified by the Priests. The covered-in space under the gates of the town was, however, given up to them. Here they took shelter from the heat of the sun and from the rain, and were very conveniently placed for receiving alms. No doubt, when it was fine, they went outside their refuge, as they do at the present day.

In our painting, the leper is seen in the middle of an almost deserted road, and is flinging himself in the path of Our Lord, to implore Him to heal him.

We read in the Gospel that Jesus, after He had wrought his cure, charged the leper to go and show himself to the Priest and fulfill the law. This law required a ceremony, curious enough. The man who was cured took two undefiled birds and a bouquet made up of a branch of cedar with one of hyssop, tied together with a band of scarlet wool. One of the birds was sacrificed and the blood received in a vessel containing water. The bunch of cedar and hyssop was then fastened to the other bird and plunged with it into the bloody water. The leper was sprinkled with this water and the bird was set free alive. The man, thus purified, was then free to return to the society of his fellow men and to the privileges of religion.

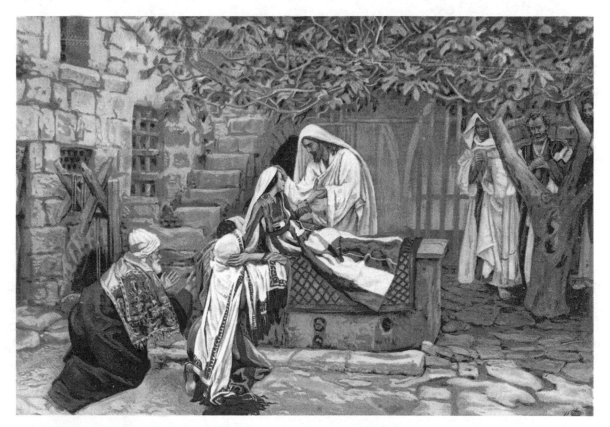

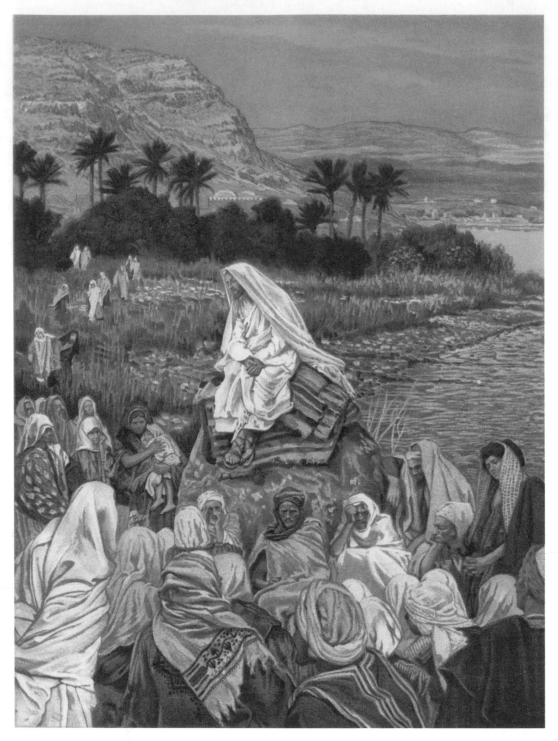

In wandering slowly on foot by the Sea of Tiberias, near the so-called Horns of Hattin, rocks occur at intervals, any one of which might very well serve as a seat for a teacher wishing to address a crowd. Why should not Jesus, Who, the Evangelists tell us, often taught the people by the sea, have used one of these very stones? It seems to us that we are quite justified in assuming that He did, especially as the surrounding districts are lofty, rendering the place very suitable to His purpose from an acoustic point of view.

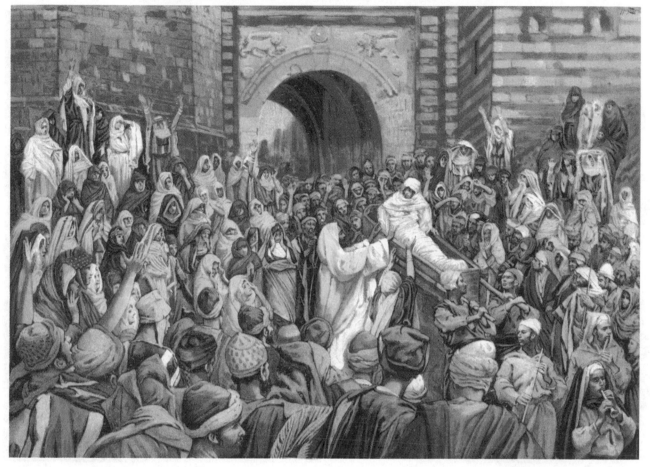

A few details about the raising of the widow's son at Nain have been handed down to us by tradition. The name of this son was Quadratus. After his resurrection he at once became a disciple of the Apostles. On this subject Eusebius, that faithful historian of the early days of the Church, quotes:

> *The actions of Our divine Saviour appealed to the eyes, because they were real; because those whom He healed and raised from the dead were visible, not only at the actual moment of their resurrection or their recovery, but for the whole of the rest of their lives, and not only during the life on earth of Our Saviour, but even after His Ascension, so that many of them have remained alive until our own day.*
> *(Hist. III, XXXVII, 17.)*

Other old traditions relate how the mother of the man restored to life was received by the company of Holy Women who ministered to the necessities of the Apostles and disciples in their journeys.

Nothing is now left of Nain but a few houses, which have escaped destruction, situated at the base of "Little Hermon" southwest of Mount Tabor. The resurrection of Quadratus was formerly commemorated by a church built on the actual scene of the miracle. The Moslems converted this church into a Mosque, which has long been in ruins. All that can now be seen is a single "mihrab," or niche, in which the lower portion of a white marble column still remains.

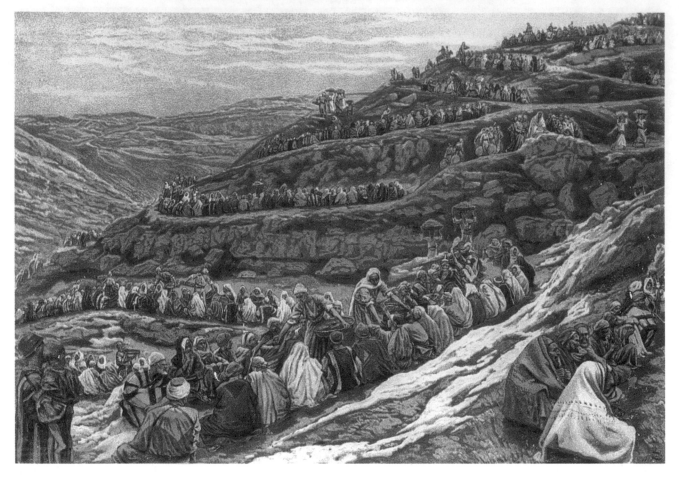

It is Saint John who relates this miracle with the greater number of personal details and picturesque touches. We find Saint Philip coming forward on the occasion in a manner specially characteristic of him, partly because he had charge of the food department amongst the followers of Our Lord, partly because his temperament led him to ask for precise explanations, as is shown in the account of the last address of Jesus to His disciples.

After the consultation with Philip and Andrew, Jesus, Who all the time knew "Himself what He would do," ordered them to make the men sit down. So the men sat down on the grass in groups of fifty or a hundred. Then the miraculous meal was served to them.

THE CORNERSTONE

The more important buildings of the Temple were built of Jerusalem limestone of a yellowish white color. The upper portion of the sanctuary was faced with white marble veined with blue, which, according to some, made it look like a mountain of snow, while others compared it to the waves of the sea. The supplementary buildings of the Temple surrounding the Court of the Men and the Court of the Women were decorated in another fashion. According to the Talmud, they were faced with red and yellow stones, which had been hewn out of certain quarries near Jerusalem and which are, at least, peculiar to this one district. The stones were arranged in a net-like pattern. That is to say, in squares resembling those of the meshes of a net or, like a red and yellow chess-board. We can get an idea of the mode

of decoration in some of the Mosques still to be seen at Cairo. In fact, Mohammedan Mosques were often decorated with something of Jewish feeling, so that they often, to a certain extent, resembled the Temple of Jerusalem.

In spite of their beautiful appearance, however, the stones we have just described crumbled away under the action of inclement weather. One or two blocks fell to pieces while the rest remained intact. No doubt, a reserve of stones was kept for replacing those thus destroyed. Some corner of one of the courts would be set apart as a work-yard for necessary repairs. There lay the beautiful stone left unused by the builders and on the brink of rejection. After a severe and damp winter, some would become so disintegrated that it had

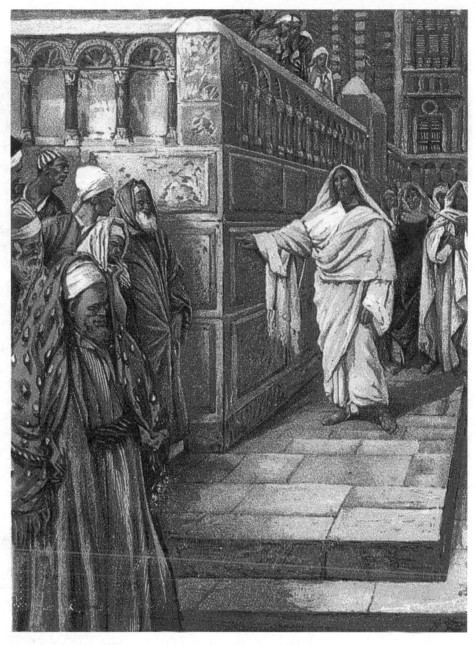

to be taken out. This lead to the substitution of the crumbled stone in a place of honor by the beautiful stone originally rejected.

This was the idea I have illustrated in my picture. I took for granted that Jesus, according to His usual custom, took an actual and well-known fact to enforce His doctrine and render it more striking. We may, however, also suppose that Our Lord merely turned to account a proverbial expression several times employed in the Bible, in Psalm 118, verse 22, for instance, which is quoted word for word in the Gospel narrative. In favor of the latter interpretation is the fact that Jesus would Himself remember the words of the Old Testament. It was from the very same Psalm that the Jews took the exclamation with which they hailed the approach of Christ on Palm Sunday: "Blessed is he that cometh in the name of the Lord."

It is morning, and in front of the Jewish notables rise the fifteen steps called the Psalms or the Degrees. On the left of these steps, beneath the green marble columns of the Court of Israel, can be seen the entrance to the rooms where the musicians keep their instruments. In the background, on the southwest, at the corner of the Court of the Women, where we now are, is the room or the pavilion, open to the sky, where the wine and oil were kept. We know that there were three other such pavilions: that of the Nazarites on the southeast, that where the wood to be used in the sacrifices was sorted, on the northeast, and, lastly, that on the northwest, reserved for the use of lepers.

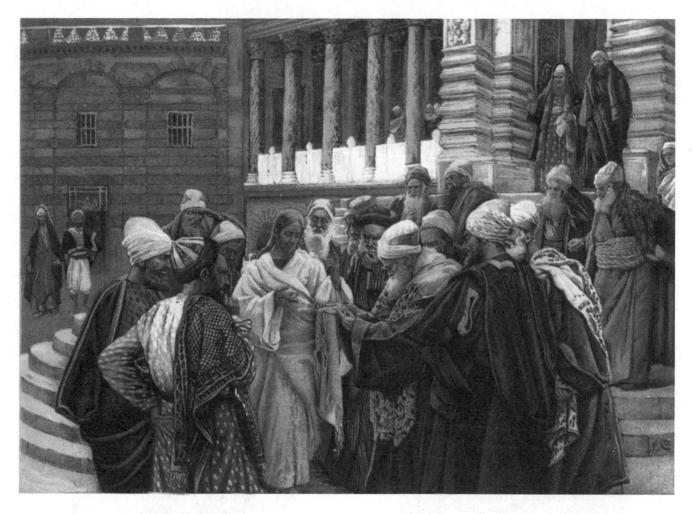

At first sight, the way in which the enemies of Jesus endeavored to compromise Him seems strange enough. They do not ask if they must pay tribute to Caesar, which, in case of an affirmative reply, might have made Him odious in the eyes of the crowd, who were intensely irritated by the fiscal exactions of the Romans. Rather they asked "Is it lawful?"—a truly singular inquiry when the very real suzerainty* of the Roman Emperor over the Jewish people is borne in mind. Never throughout the whole course of the history of the Jews had they refused to pay tribute to the suzerain, whether that suzerain ruled from Nineveh, Babylon, or Persia. The Pharisees, however, had found means to arouse scruples on this point, and the people would evidently have been ready enough to adopt them. But Jesus, perceiving their craftiness, simply said, to put them to confusion, "Show me a penny." The current coin no longer bore the proud device engraved on that in use in the time of the Aesmonean or Maccabean princes, Jerusalem the Holy, but simply the effigy of the reigning Emperor Tiberius. The consequence was evident enough, the superscription convincing: they had to pay. For all that, however, the answer of Jesus did not prevent the Pharisees from saying later to Pilate: "he forbids the giving of tribute to Caesar."

*dominion, authority

MARY MAGDALEN

Jewish etiquette did not permit women to sit at table with men, or even to remain in the same room with them during a feast. A kind of alcove, or some such recess near at hand, was generally set apart for them. The recess was separated from the rest of the apartment by a grated or open work partition. Through this partition the women, without being too much in evidence, could look on, and, to a certain extent, share in the festivities, hear the various speeches, and listen to the songs and to the music of the instruments, which added to the bright and festive character of the entertainment.

The low table was generally of a horse shoe shape, and the guests reclined on the outer side of the circle, leaning on the left arm, so as to have the right arm free. The women did not eat with the men, but generally remained in the aforementioned adjoining room. They could thus see all that was going on and if necessary give an opportune word of advice, as Mary the mother of Jesus did at Cana.

With a room thus arranged, and bearing in mind the ready hospitality of Oriental houses, Mary Magdalen could quite easily slip in unperceived behind the guests. Draped in her garments of penitence, which attracted no attention, she was able to pass like a shadow behind Jesus, break open the flask of perfumed ointment she had brought with

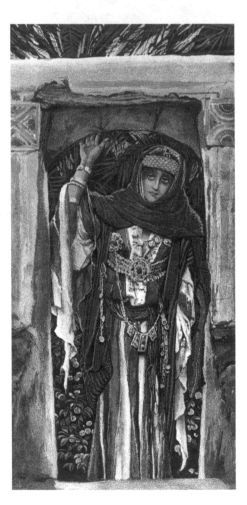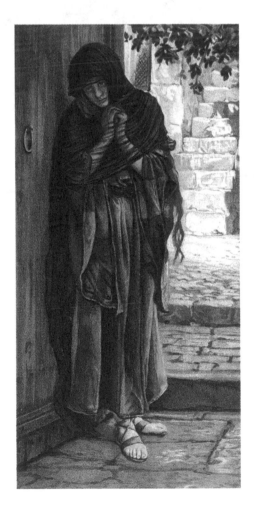

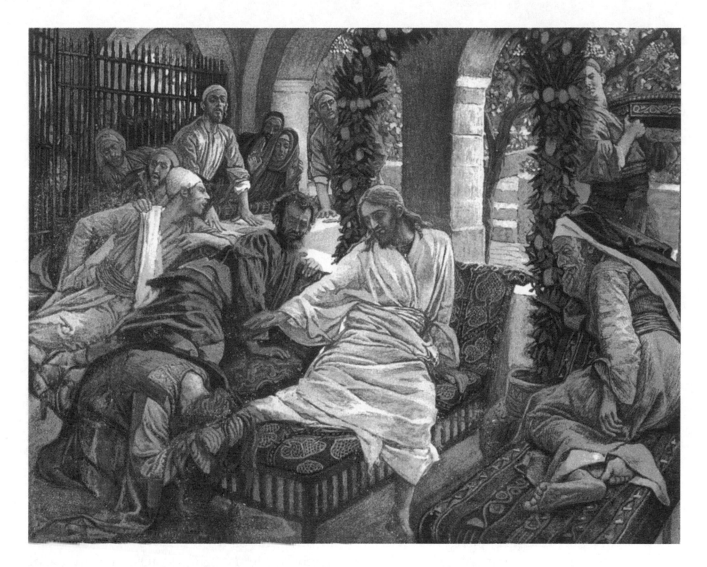

her, and pour a little of its contents on the head of her Master. Then, kneeling down, she spread the rest over His sacred feet, which she was able to reach without difficulty as they rested on the couch.

Her anointing finished, she proceeded to wipe away the surplus ointment with her long hair. The house was filled with the penetrating and medicinal odor of the spikenard, which was then much used in religious worship and at funerals. Her act of pious homage duly performed, Mary Magdalen was for stealing quietly away. However, the scent of the ointment betrayed her and gave rise to the disparaging remarks and murmurs against her by the guests, especially Judas.

This incident, in fact, seems to have given the final blow to the wavering fidelity of that disciple. He began boasting, talking about the necessity of economy, and pretending to take a great interest in the poor. Really, as Saint John points out, Judas only betrayed his own avarice and dishonesty, which were already notorious. Jesus, having rebuked him before everyone by His high commendation of what Mary Magdalen had done, the unfortunate Judas, wounded to the quick and already a traitor at heart, rose from the table and went out to put his evil design into execution.

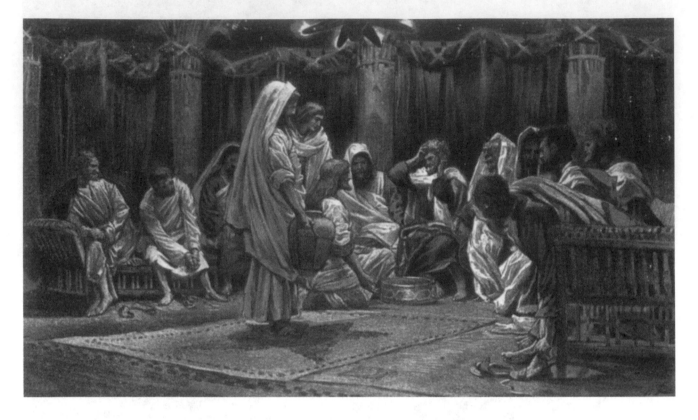

Their Paschal duties performed in accordance with the requirements of the Jewish law, and before the inauguration of the new rite which Jesus was about to institute, the Lord and His disciples left the room in which they had kept the Passover, to repair to another divided into two parts by a curtain, on one side of which seats were provided for the new ceremony. On the left, at the edge of the table, is Judas, succeeded by Saint Thomas, Saint Bartholomew, Saint James the Less, who is bringing the water, Saint James the Greater, and then Saint John, who is looking down at the basin in which the feet are to be washed. The Saviour has taken up His position in the center of the group, having on His left, that is to say on the right of the picture, Saint Peter, Saint Andrew, Saint Thaddeus, Saint Simon, Saint Matthew and Saint Philip. Jesus has begun with Philip, who is putting on his sandals again. The scene with Saint Peter, described in the sacred text, will take place in the center, and the ceremony will conclude with the washing of the feet of Judas.

THE LAST SUPPER

The disciples had already been profoundly moved by the washing of their feet by the Lord. The mysterious words Jesus had just pronounced over the bread and wine had put the finishing touch to their emotion. At heart, in spite of all the comforting words their Master had lavished upon them, they are anxious and saddened by their presentiment of the events about to take place. They are all silent. Jesus alone says a few words in a low voice. He breaks the Sacred Bread and distributes it amongst the disciples, who reverently approach to receive.

Such is the subject of my picture, which repudiates the idea that the Eucharistic bread was passed from hand to hand, beginning with that of Jesus and ending with the most distant of the disciples. This would have made it appear as if the Apostles had not had the consolation of receiving direct in each case the token of their Master's infinite love for them. I have therefore supposed, as indeed the sacred text seems to suggest, that Saint John and Saint Peter, placed on the right and left hand of Jesus, were the first to communicate. The other Apostles came in turn one by one, with feelings suitable to a moment so supreme, to receive the same great privilege.

The Church was now founded. It was fitting to inaugurate a ceremony, which was to be repeated throughout all future centuries, in such a manner as to impress all who were present with the solemnity of the sacred rite and enable them ever to retain undimmed their memory of it.

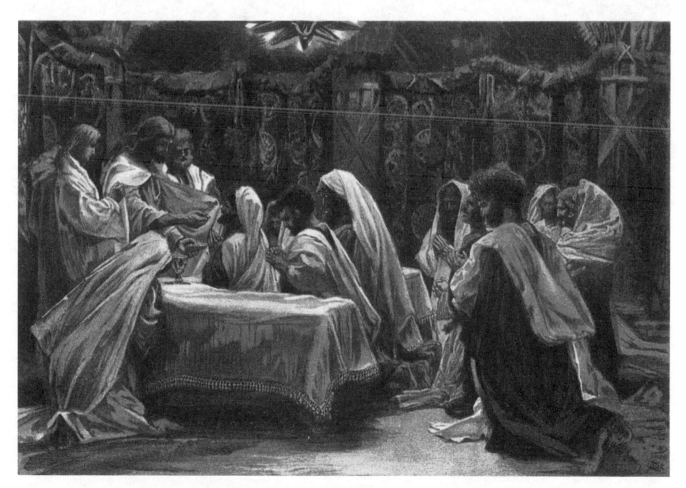

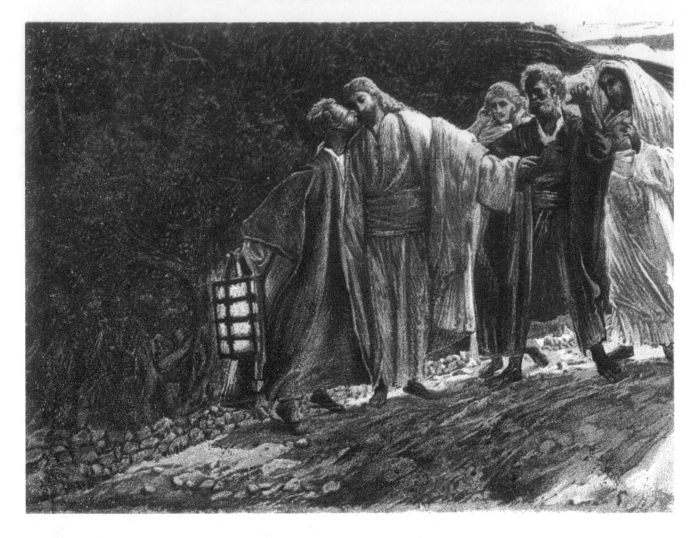

The treason is accomplished now. From the shadows of the trees issue the satellites forming the escort of Judas, who press forward in disorder to seize the Lord. The Master, seeing that they were arresting the Apostles also, exclaimed: "I am he!" Anxious to have it fully understood that He surrendered voluntarily, He, almost for the last time before His death, availed Himself of His supernatural power. *As He pronounced the simple words: "I am he!" the soldiers were all flung backward by an irresistible force and fell to the ground.

*Editor's Note: This was the second to last time Jesus used His supernatural power before He died. Can you think of the last time? (See pages 82-83.)

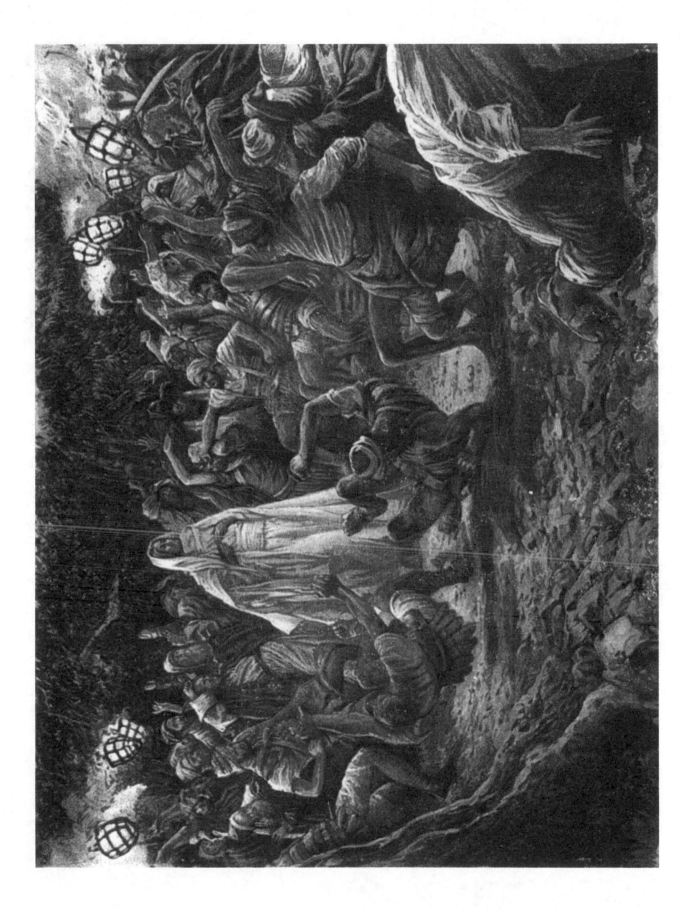

THE BRIDGE OVER THE BROOK KEDRON

According to an ancient tradition, which reappears in the visions of Anne Catherine Emmerich, Jesus, as He was passing over the Kedron bridge, received a treacherous push by order of the Pharisees, and was flung into the torrent. The words: "De torrente in via bibet"* were thus literally fulfilled.

It is somewhat difficult to understand what object the Jews can have had in inflicting this cruel indignity on the Lord. But they meant to bring about the death of Jesus, no matter at what cost. As the bridge they were crossing had no parapet, it seemed a good opportunity to get rid of Him without any noise or fuss.

Had they succeeded they would have avoided a double danger. To begin with they would have averted a popular tumult, the fear of which had so much troubled the Sanhedrin at the last meeting. And then, would it not be more prudent to finish the matter off while the Jews had Jesus in their own power? Let Him come into the hands of Pilate and who could say what would happen? Perhaps the false charges brought against the prisoner would seem of no account to the indifferent Roman procurator. Suppose he should set at liberty the Man Who was so fatally undermining their influence? At this thought they became capable of anything. There would have been nothing surprising if they had bribed one of the guards to put their captive quietly out of the way in such a manner that no suspicion of murder should fall upon the instigators of the crime.

The brutal action, if it were committed, must have made a vivid impression upon the mind of the traitor who was still present, already tortured as he was by remorse. We may well believe that the sad and dignified bearing of the Master as He called him "Friend" when He received the kiss, succeeded by the miracle of the healing of the ear of Malchus and the supernatural falling back of the guards, must have given Judas plenty of food for reflection.

Now that the ferocity of the enemies of Jesus is freely manifested and he [Judas] can foresee all the consequences of his treachery, he cannot fail to be seized with terrified foreboding and to look back with horror upon the atrocious action of which he has been guilty.

*"He shall drink of the brook in the way."
Psalm 110, v. 7

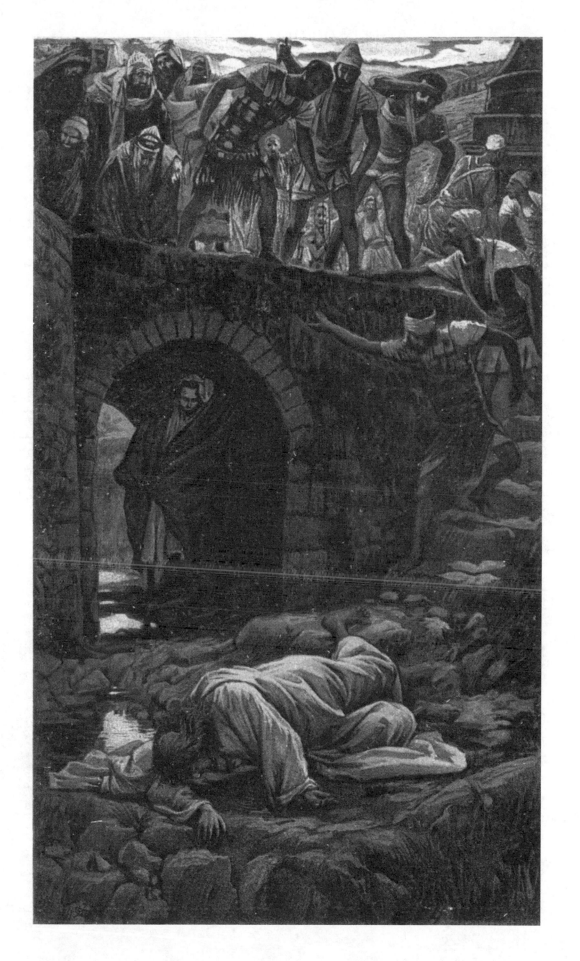

63

The Mocking of Christ

The subject now represented takes us back to a little before the third denial of Peter, or at least to before the Lord turned and looked at him. (We assume that the look was given on the way to prison.) Jesus once condemned by acclamation on the suggestion of the High Priest, a nameless scene of horror began. The Sanhedrin, instead of protecting Him from the crowd, as in such a case it was the duty of the legal authorities to do, abandoned Him to their mercy and thus sanctioned the worst outrages. It is true that the members of the Supreme Council did not themselves take any part in the insults heaped on Jesus, but there is not the slightest doubt that they were as responsible as if they had, for they certainly could have prevented them. His persecutors flung themselves upon the Prisoner with a positively diabolical fury, raining blows upon Him, "spitting in His face, buffeting Him and smiting Him with the palms of their hands." They blindfolded Him with a dirty rag, and as they struck Him they mocked Him, saying: "Prophesy unto us, thou Christ, who is he that smote thee?"

Truly the unfortunate Victim paid dearly enough now for His brief triumph on Palm Sunday, for the precious ointment of Mary Magdalen and for His few short moments of joy, which He must now expiate with all this agony and humiliation. The enemies of the Prophet cannot but have been intoxicated with the thought of having Him, Who had previously caused them so much anxiety, in their hands under such conditions. But the night was far spent, even the tormentors were getting weary, and there was no longer any danger of the escape of their Victim. The crowd now melted away and the guards led Jesus away, with soiled garments, bleeding face, and limbs bruised by the blows He had received and galled by His fetters. He had now been bound some four hours, it being three o'clock in the morning, that is to say, eleven hours since He was taken prisoner.

Long before, Job had said, and his words were perhaps prophetic of the sufferings of Christ: "They have gaped upon me with their mouth, they have smitten me upon the cheek reproachfully; they have gathered themselves together against me." These words were literally fulfilled in the scene we have just described. Yet more remarkably true was the beautifully worded prophecy of Isaiah, when he glorified beforehand the divine gentleness of the insulted Messiah, saying: "I gave my back to the smiters, and my cheeks to them that plucked off the hair; I hid not my face from shame and spitting."

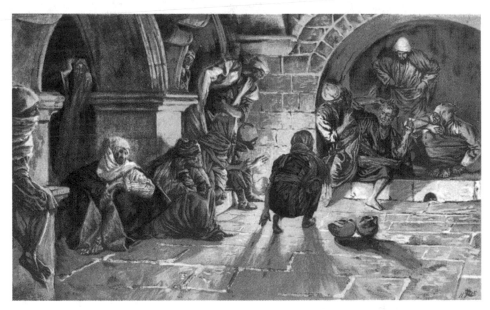

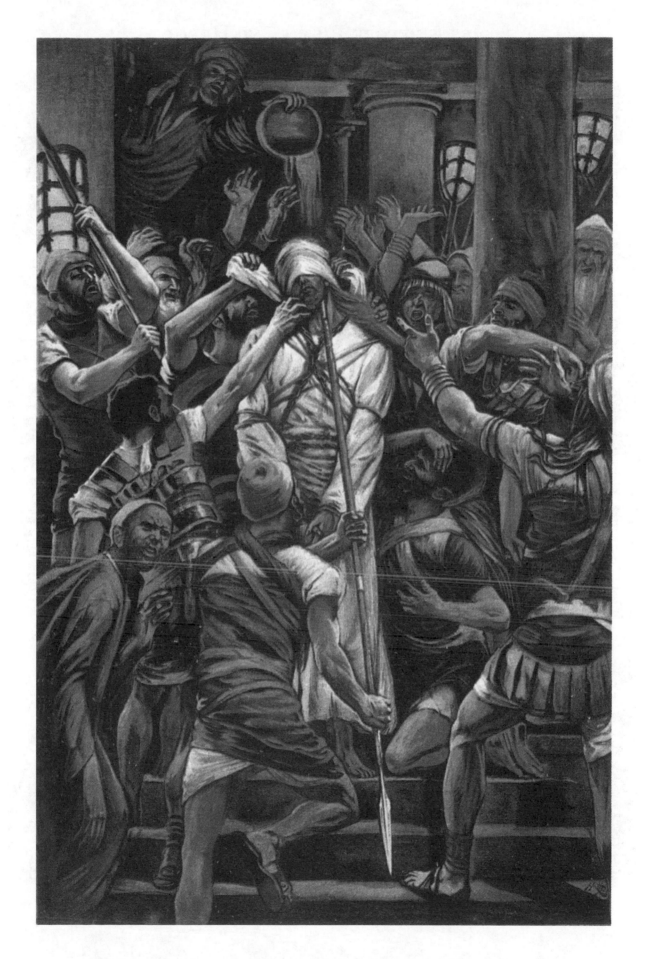

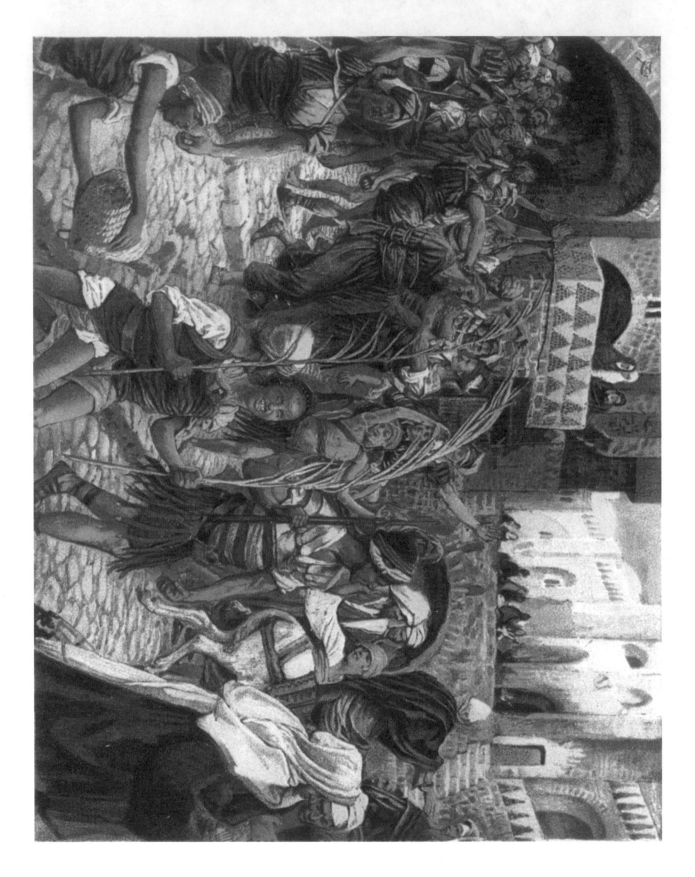

The crowd accompanying Jesus hastened down the steep streets leading from the Sion to the Roman quarter of the town where the Praetorium was situated. There, in the Antonia Citadel, dwelt Pilate the Governor, and in it also were the barracks of the Roman garrison. Jesus has been stripped of the garments He had worn when He had left the guest-chamber the evening before. They were much soiled, and bore witness all too clearly to the cruel treatment to which their wearer had been subjected during the night. If the Governor had seen them he might have turned their condition to the advantage of the prisoner, for he might have chosen to consider the state they were in as an insult to his own dignity, as well as an outrage on humanity. Jesus therefore wore nothing but his seamless undergarment. The rest of His clothes, which were of a reddish color, were not restored to Him until just before He was compelled to carry His cross.

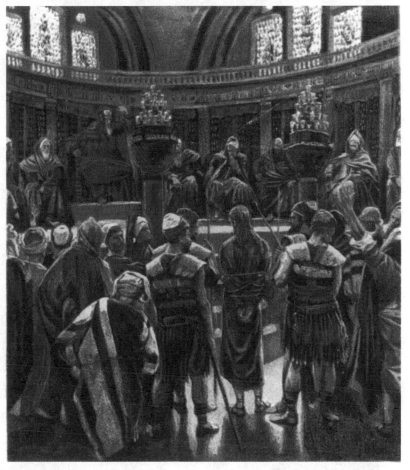

The procession went down the Tyropocon valley which was crossed by means of bridges. The crowds which had collected the evening before were now augmented by a fresh concourse of people. The judges, before whom Jesus had been taken in the morning, were hastening along on donkeys with their scribes to be present at the examination by the Governor. They stand in great dread of the Roman representative, for the contempt with which he treats them on every fresh opportunity does not tend to inspire them with confidence. They feel that they must be on the spot to accuse Jesus and, if need be, to rouse up the people and incite them to demand the death of Him they have themselves already condemned.

The weather is now overcast, a slight rain fell in the morning and still continues to fall at intervals. The road is slippery and many fall by the way. Jesus Himself is wet through. In the lower quarters of the town where the people had been aroused during the night by the tumult which had been going on, the excitement and disorder have begun. Everyone is already flocking in the direction of the Antonia Citadel, where the events of the new day are to be inaugurated.

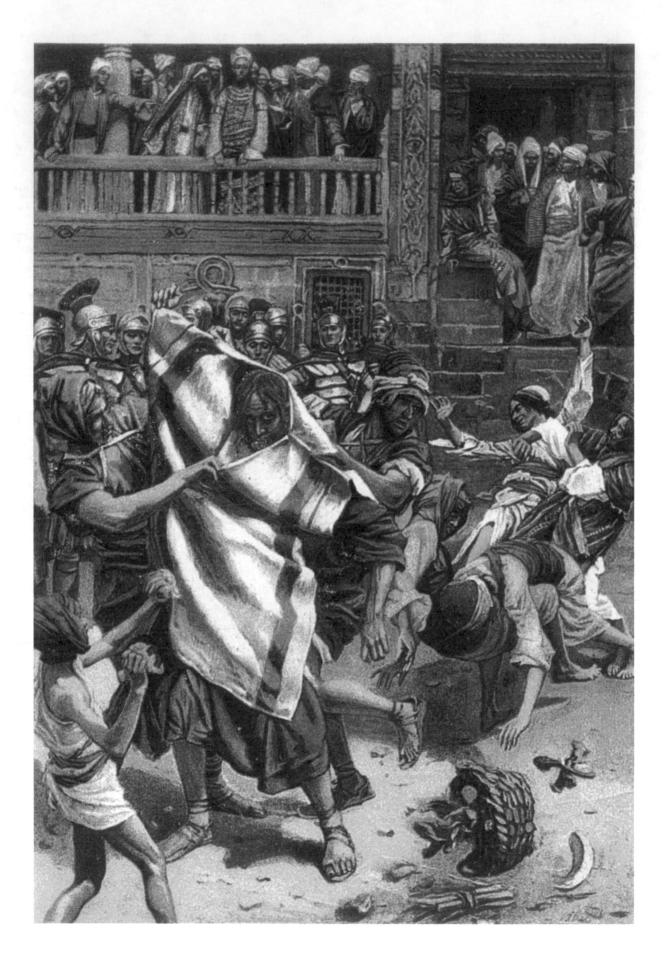

The decision of Pilate to send Jesus back to Herod appears to have had a twofold motive. In the first place he wished to get rid of a galling responsibility, and in the second he wished to pay his court to Herod, with whom, as the sacred text implies, he was at enmity. In setting himself to curry favor with Herod, Pilate little expected how well he would succeed. The tetrarch, blasé as he was from self-indulgence, anticipated a new pleasure in witnessing the marvellous works with which he hoped Jesus would entertain him. He no doubt took the Saviour for a kind of Simon the magician, who would be only too glad to win His liberty and the favor of the king by performing some wonderful feats of jugglery. Herod was very quickly undeceived. At the very first glance, the sight of the Nazarene must have affected him disagreeably. Jesus, it must be remembered, had been at the mercy of the populace since the morning. He had nothing on but His seamless garment. He was in far too wretched and miserable a plight for His appearance to have given any pleasure to Herod.

For all that, however, he received the Prisoner with a certain amount of empressement,* overwhelming Him with a great flow of words and asking Him many questions. All of which Jesus answered only with a silence full of majesty. It was a humiliating lesson for Herod. This so-called King of the Jews seemed to take His title seriously and to look upon the tetrarch with absolute disdain. Herod was deeply wounded. The members of the Sanhedrin were there, vehemently accusing Jesus. Herod, though he does not believe all their angry accusations, means to have his revenge for the wound inflicted on his own self-love, and with this end in view he begins to mock the Prisoner.

This pretended King Who has been brought before him, is really too carelessly dressed. His royal purple is in too bad a condition, let us give Him a gorgeous robe more worthy of His sovereign dignity! Some old rags of white stuff are therefore hunted up from some neglected corner of the Palace, some comic-looking, tattered garment in which holes can easily be made for the head and arms, and behold there is Jesus arrayed in fitting guise for a pretender to the throne! A white garment was in fact worn by candidates for a crown, and this garment resembled the gala dress of the wealthy and highly born. Thus arrayed, Jesus was sent back to Pilate before whom He had already been brought, Herod abandoning his rights.

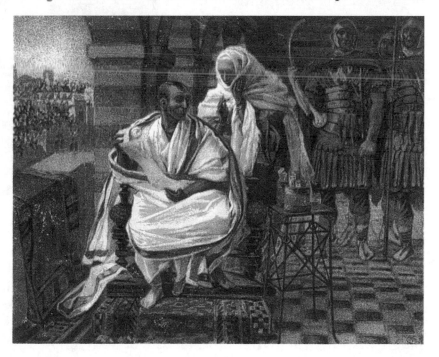

*interest, eagerness

The Scourging at the Pillar

The column to which Jesus was bound during the scourging is probably the one alluded to by Saint Jerome, which he and Saint Paul alike had venerated. It upheld the portico of a church in the Sion quarter, to which it had been removed by Saint Helena. In every court of justice there was a scourging column, and the one in question was probably originally in the forum or public square opposite the Praetorium. There was also, most likely in the court of the Guard-house, another short column to which Jesus Christ was fastened when He was crowned with thorns. This was called the Column of Reproach, and is still held in high honor in the Church of Saint Praxedes. It might perhaps be the column from the Tribunal of Caiaphas to which Our Lord was bound during the night of Holy Thursday. It was taken to Rome in 1223 by Cardinal Colonna. It seems very far from reasonable, after the lapse of no less than six centuries, for it to be allowed to come into competition with the one which Saint Jerome, writing in the year 430, asserts to have been the true Column of Scourging.

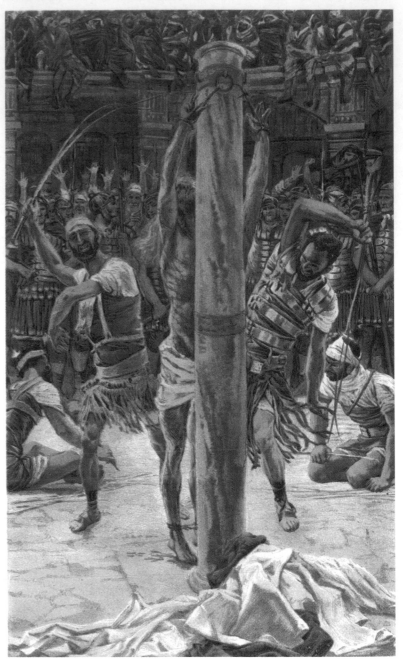

In our picture we have represented the Forum with a number of shops at the further end, closed just now on account of the crowds which have collected. We have supposed, in accordance with certain traditions which have come down to us, that Saint John, who had accompanied the Blessed Virgin, may have secured a place in one of these shops from which he was able to watch all the sufferings of his divine Master. From this vantage point, when Jesus had been compelled to carry His cross and had started for Calvary laden with it, His divine Mother was able to follow the melancholy procession. Guided by Saint John, she was able to take a short cut so as to meet her Son again on the Via Dolorosa a little farther on.

THE CROWN OF THORNS

The crown of thorns is supposed to have consisted of a band of rushes from the seashore, strengthened with twigs of a prickly thorn twisted in and out. Its appearance must have been rather that of a domed crown than of a simple wreath, which would merely have rested on the forehead, leaving the head itself uncovered. The expression of Saint Mark, 15:19, "And they smote him on the head with a reed," as if to force the crown down on His brow, would appear to lend color to our idea that it covered the head entirely. The twigs of thorns went all the way around the edge of the crown.

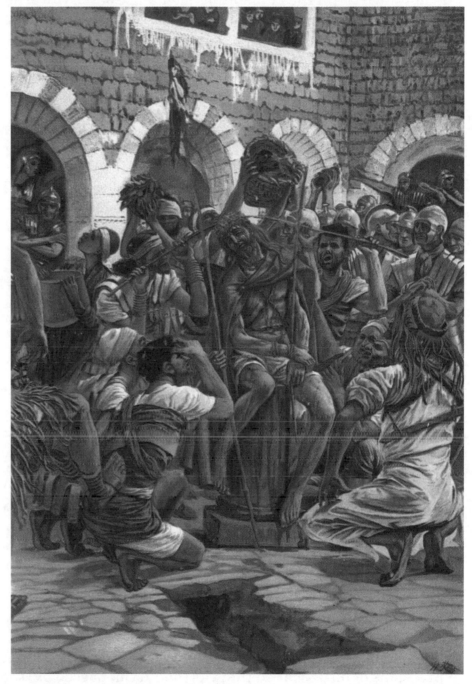

The band formed of rushes, which was the foundation of the sacred crown of thorns, is still to be seen in the Cathedral of Notre Dame at Paris. The single thorns and twigs which made up the rest of the instrument of torture, preserved in other sanctuaries, are in a sufficiently good state of preservation and would evidently fit well onto the band. It is possible to form a very accurate idea of what the crown must have been as a whole.

This precious relic passed into the hands of Saint Louis while almost intact, after having belonged for many centuries to the Byzantine Emperors. Later, the thorns were taken off and distributed amongst the various sanctuaries where they are still to be seen.

"Let Him Be Crucified"

The crowd now occupies the place where Jesus had been scourged, with the column by which He had suffered rising up in the midst. The crowd could go up to the forum, which was reached by a few steps, and from thence could look on at the ceremony of giving judgment and hear announced the decisions of the presiding judge. On the right and left were the arches upholding the Palace of the Governor, one of which still exists, walled into the Chapel of the Convent of the nuns of Sion.

Pilate had hoped that the dramatic effect of *Ecce Homo*, with the sight of Jesus in His suffering condition, would have aroused the compassion of the mob and saved him from the odium of pronouncing a judgment for which his own conscience reproached him. Who, he had thought, could resist the effect of the sudden apparition of that bleeding spectre? That head crowned with thorns, that face wounded by repeated blows, that lacerated body drooping with fatigue, covered with sweat and displaying terrible, bleeding wounds, those bound hands in which quivered the reed sceptre, was not all this enough to rouse the pity of the most hardened and most barbarous hearts? He was mistaken. He had reckoned without making due allowance for the thirst for blood natural to an excited mob and without remembering the intrigues of the Sanhedrin, who were circulating amongst the crowds, suggesting the cry raised all too soon for the death of Jesus.

In spite of his benevolent intentions, which became more decided after the message from his wife Claudia, Pilate, thanks to his weakness and successive concessions to the clamor of the people, only succeeded in adding to the sufferings of Jesus. Anxious to make yet one more effort, he proposed that he should release the accused in honor of the Passover. It was, in fact, the custom for the Roman Governor to release a prisoner at that Festival. But Pilate, at the same time, felt bound to give them a choice, and he therefore said:

"Whom will ye that I release unto you? Barabbas, or Jesus which is called Christ?"

Barabbas had been arrested in a recent tumult. The choice of the people would seem strange if we left out of consideration the way in which they had been plied with suggestions by the Chief Priests. Moreover, this Barabbas, who was probably a Zealot and a Galilean, would appear to have been popular. Then, again, the solemn teaching of Jesus must have been very unpalatable to many, while the coarse jokes and swaggering boasting of the agitator appealed to the sympathies of the mob.

The crowds parted to admit him when he was set free, with every manifestation of joy, and it was Jesus, their benefactor and Saviour, Whose death they wished to secure. More than one of the Lord's friends must, however, have been amongst the ever-increasing masses of people, but fear closed their lips, and when, later, a few expressions of pity escaped them as the Victim passed by, they had absolutely no effect upon the relentless populace.

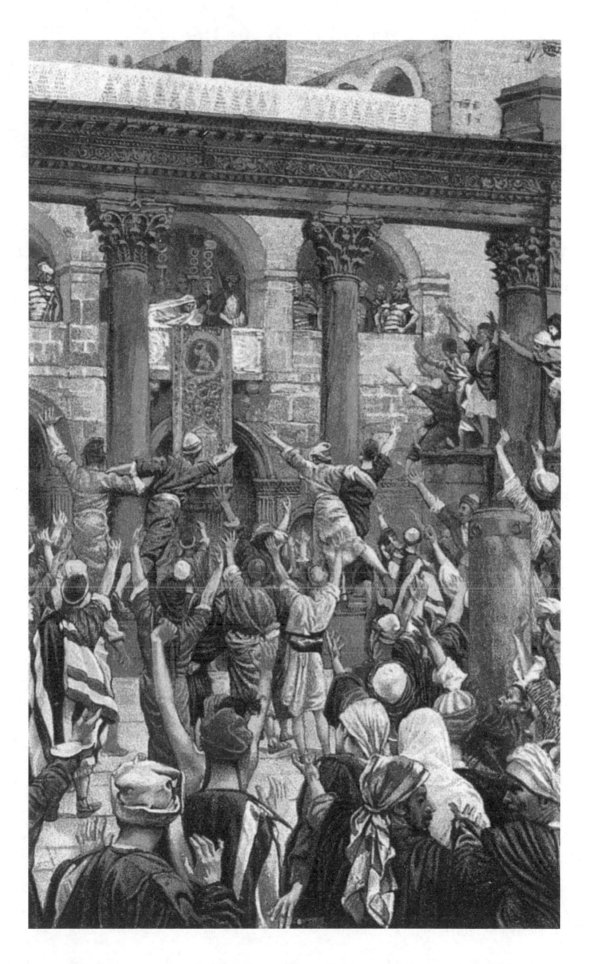

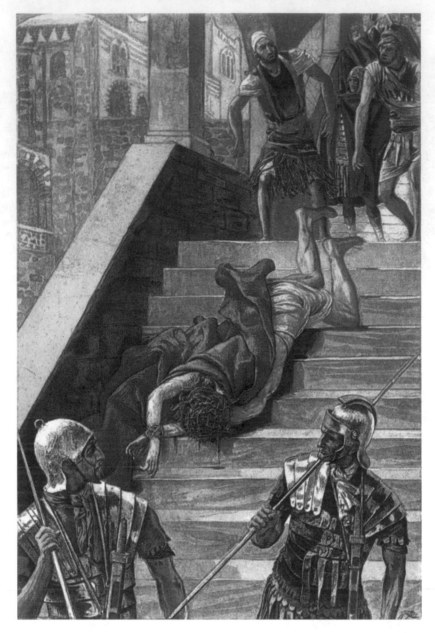

The flight of steps to which the name of "La Scala Sanctus" or the "Holy Stair" has been given is still to be seen at Rome, where it was removed by Saint Helena. It is of white marble veined with grey, and it led up to the Roman Praetorium. Nothing which has been preserved to us connected with the Passion of Our Lord is more worthy of the veneration of the pilgrim than are these steps, which were actually trodden by His sacred feet. Even the Via Dolorosa is less exactly what it was at the time when Christ passed along it and His blood stained the ground; for, of course, the level of the soil has been raised and modified. Whereas, in the sanctuaries enshrining the more enduring relics, marble facings keep worshipers to some extent at a distance.

Pilgrims to the Scala Sanctus touch the very steps down which, according to tradition, Jesus, Whose feet slipped at the top, rolled all bruised and bleeding. For this reason the Holy Stair is always climbed on the knees.

Pilate and his assistants had now left. The scarlet military cloak in which the Master had been put to derision is taken off His shoulders. Blood flows afresh as the wounds are re-opened. The crown of thorns is torn from the Victim's brow, in order to pass over His head the seamless vesture for which lots will be cast on Calvary. The Saviour's white robe is then restored to Him, together with His sash, sandals, and lastly His cloak. According to tradition, certain pious believers had taken charge of the garments of the Master when they were taken off after the ill-treatment He had received in the house of Caiaphas. There had been time to have them cleaned and mended. We are, we think, justified in supposing that all through His Passion Jesus was allowed to retain the under garment of linen which Jews then wore about the loins next to the skin and which was fashioned something like the under drawers of the present day. If so, He was never naked even on Calvary, but I feel bound to add that few agree with me on this point.

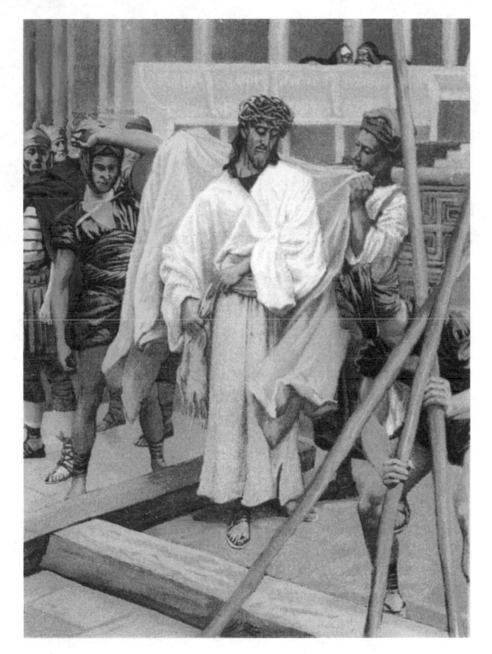

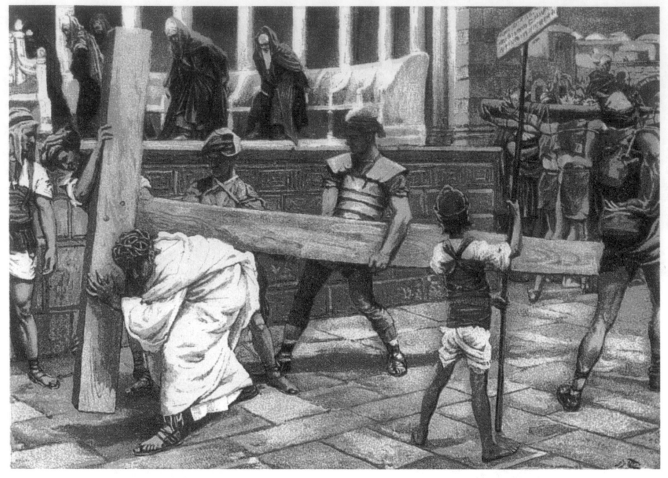

Crucifixion is a very ancient mode of execution, and the form of the cross varied greatly. It seems to have been at first a mere stake to which the condemned was either bound or nailed, modified later by the addition of a transverse beam or branch. The name of the cross was determined by the way in which this transverse piece of wood was fastened on. If it sloped much it was called a *crux decussata*, literally, an oblique cross. This was the form now called Saint Andrew's Cross, and it resembled the letter X. If the second beam were placed across the top of the main stake the cross became a *crux commissa*, now often called Saint Anthony's cross. When the central beam rose somewhat above the transverse one it formed a *Crux immissa*, which is now known by the name of the Latin cross.

To which of these three types the Cross on which Jesus suffered belonged is difficult to determine. It certainly was not that which is now known as Saint Andrew's; but with regard to the other two forms, the choice is difficult. Many authorities consider it certain that the Latin form was used. They rely upon the way in which the early Fathers of the Church speak of it, comparing it to the Roman standard, to a bird in flight, to Moses praying with outstretched arms, all expressions which may be said justly to apply to the traditional form. Still, this does not really prove anything, for figures of rhetoric and popular similes are never particularly exact. Something far more precise in the way of evidence is needed. Moreover, it must be observed that whatever was the form of the Cross when it was laid upon the shoulders of Jesus and He was compelled to carry it, it must

necessarily have been converted into a *Crux immissa* by the addition of the tablet bearing the superscription which so enraged the Jews. As for the examples of early Christian art which have come down to us, neither do they prove anything for sometimes the Latin cross and sometimes that forming the letter T is introduced.

The street is terribly steep and the big stones with which it is paved are slippery, so that Jesus, exhausted with fatigue, falls beneath His burden. Those in attendance on Him are in no mood to give Him any assistance. They only jeer at and insult Him, pouring out opprobrious epithets upon Him. All around, however, are crowds whose attitude is rather more noisy and excited than positively hostile. "A great company of people followed him," says Saint Luke, and there was nothing surprising in the numbers which had come together, for executions always attract a concourse of people. Moreover, it was the time of the Passover, and, that festival was always attended by vast multitudes, all of whom had been from the commencement of the trial deeply interested in the fate of the Prophet about Whom there had been so much discussion. Jesus, as He falls, seems in my picture to be appealing to the bystanders for a little help in His need. Shall we not do well to remember that it was for us that the Saviour suffered so long ago as well as for those living at the time?

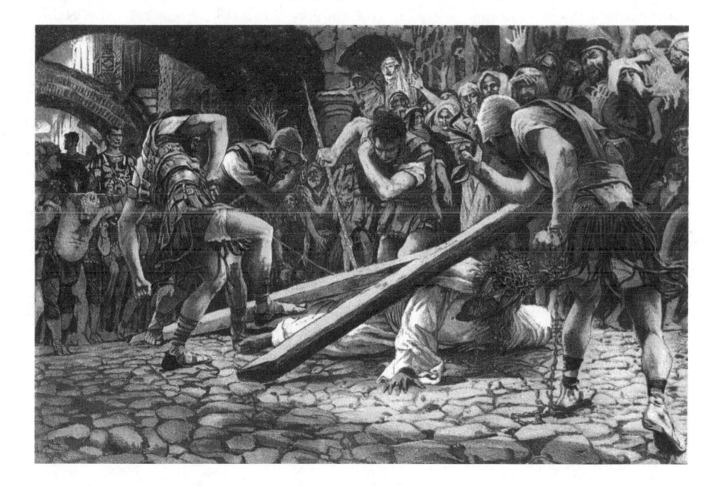

Jesus Meets His Mother

The meeting of Jesus with His Mother is not referred to in the Gospel narrative, but tradition is unanimous in asserting that it took place at the fourth Station of the Via Dolorosa. Mary was accompanied by Saint John, Mary Magdalen and Mary Salome, with other Holy Women, who, the Evangelists tell us, followed the Master to Calvary.

It was very natural that the Mother of the Lord should have been present in the Forum at the scourging, though at a distance, and should have witnessed from afar the *Ecce Homo* incident. She should have seen all that the rest of the crowd did. When the procession began to move off on its way to Golgotha, Mary, who had just heard the sentence of death passed upon her Son, and who had seen the Cross placed upon His shoulders, tried to get near enough to Him to help Him with His burden. It was impossible, for the narrow street was already blocked up with soldiers and the crowds accompanying the Victim. The Virgin was, therefore, compelled to take another route. After a most careful examination of the district, we feel able to assert pretty confidently which way she went.

A tradition tells us that in the angle formed by the street leading to the Sheep-Gate and the Tyropoeon Valley, or Valley of the Cheese Merchants, there was a house with courtyards and outbuildings belonging to Caiaphas, in the Sion quarter. Now Saint John had relations amongst the attendants of the High Priest, and it was thanks to this circumstance that he was able to secure the admittance of Saint Peter. He would thus also be able to let the Blessed Virgin and her companions pass through the courts and gardens of this house. Cutting diagonally across from one street to another, he managed for the little party of friends of the Master to arrive at the fourth Station of the Cross in time to meet Jesus, without having to go up the steep ascent climbed by the procession. The locality speaks for itself in a remarkable way. No one who has considered the matter can fail to feel sure that the meeting between the Mother and Son took place on the spot indicated above and nowhere else. It is generally supposed that the fall of Jesus occurred at the very moment of the touching meeting.

This is what Anne Catherine Emmerich says on the subject:

> *Then one of the executioners asked of those standing by: Who is that woman lamenting so bitterly? And some one replied: It is the Mother of the Galilean. Then the wretches loaded the unhappy Mother with insult and mockery, they pointed at her with their fingers, and one of them took the nails which were to fasten Jesus to the Cross and struck Him with them, mocking Him before the eyes of the Blessed Virgin. As for her, she gazed upon Jesus and, overwhelmed with grief, was obliged to lean against the door to save herself from falling. She was as pale as death and her lips were livid.*

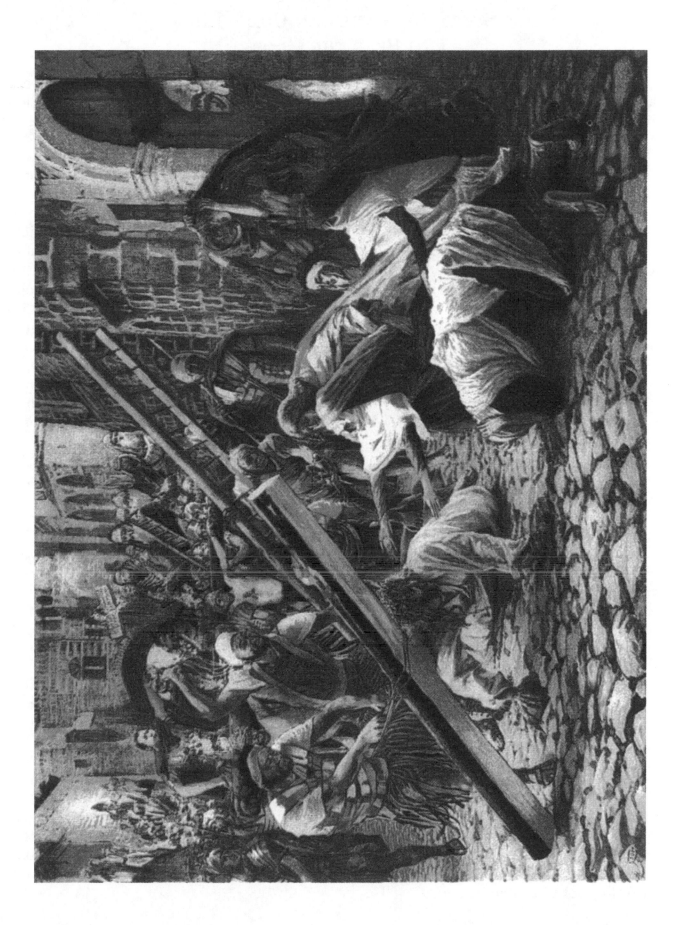

SIMON THE CYRENIAN COMPELLED
TO BEAR THE CROSS

When Jesus fell the second time, his enemies began to be uneasy. He would never, they feared, get up the ascent to Golgotha without help. They therefore resolved to let Him have a little assistance, and the man named Simon happening to be at hand, they compelled him to carry the Cross.

This Simon came from Cyrene, a province situated on the northern coast of Africa, where there was then a very numerous colony of Jews. It would appear that he was domiciled at Jerusalem, for the Gospel narrative says he was passing by "coming out of the country." He was, adds Saint Mark, the father of Alexander and Rufus, which proves that all three were known to the Evangelists at the time of the compilation of the sacred text. It is, in fact, supposed that these sons of Simon, Alexander and Rufus, were converted to Christianity later and became deacons of the early Church. In the Epistle of Saint Paul to the Romans occur the words: "Salute Rufus chosen in the Lord," and the Roman martyrology includes Simon of Cyrene amongst the Saints. Some even say that he became Bishop of Bostra in the Syrian Desert, and that he was burnt to death by the heathen authorities.

Critics and commentators eagerly discuss the question of whether he was or was not a Jew. Certain indications sanction the belief that he owned a small farm near Jerusalem, and there also seems reason to suppose that he was identical with Simon the tanner mentioned in the Acts of the Apostles, who certainly was a Jew. On the other hand, it seems a most extraordinary thing for a Jew to be compelled to bear a burden of any kind at the time of a great festival. The question must, therefore, remain undecided for the present, but the assertion that Simon was of Cyrene does not really affect the matter at issue, for, as already mentioned above, there were many Jews in that province.

Another point in dispute is whether the Cyrenian carried the Cross the rest of the way alone or whether he merely shared the burden with the Master. The Gospel narrative would appear to favor the former interpretation of the incident, but it might also be taken to mean the latter which was the most prevalent belief amongst the early Christians, and as a result was generally adopted by painters.

We think, therefore, that we are fairly justified in assuming that Jesus bore the upper part of the Cross with the transverse beam and that Simon merely upheld the long heavy central beam, the dragging weight of which added so greatly to the burden of the Victim.

Another very natural suggestion has been made and that is that we owe to Simon and his two sons the account of all that passed until the arrival of the Master at Calvary. As a matter of fact, they were of course able to see and hear everything. They were indeed the only witnesses who could do so, for none of the Apostles were near. Saint John, the Blessed Virgin, and the other Holy Women were unable to follow Jesus except afar off, on account of the crowds and the narrowness of the streets. They did not all meet again until they got to Calvary itself.

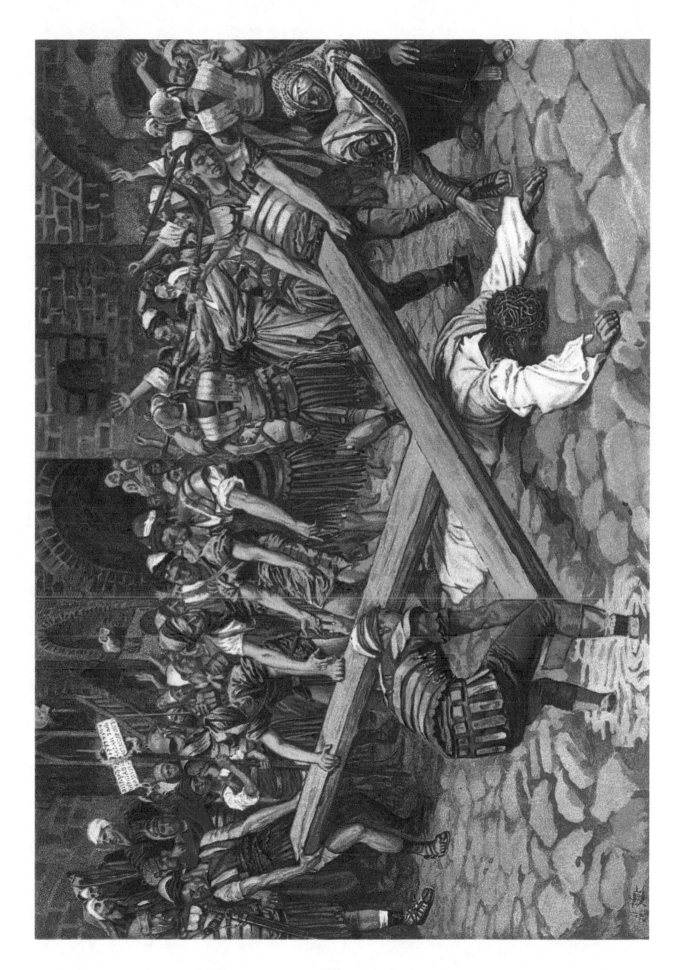

81

Saint Veronica

Jesus is still painfully toiling up the long narrow street skirting along one of the inner walls of the town and leading up to Calvary. The higher He climbs the more slowly He goes. He is panting for breath beneath His load, in spite of the help of the Cyrenian. From time to time He is compelled to pause, altogether overwhelmed with fatigue and exhausted from the loss of so much blood.

Tradition now intervenes with a touching story of how a lady of Jerusalem, a great lady connected with many of the chief Jewish families and, moreover, secretly in intimate relations with the family and friends of Jesus, approached the Sufferer, eager to do something to console Him. According to some accounts, her name was Berenice, but Anne Catherine Emmerich speaks of her as Seraphia, the wife of Sirach, a member of the Sanhedrin. Whatever her original name may have been however, she has ever since been known in Catholic tradition by the symbolic title of Veronica, from the words *vera icon*, signifying true portrait, and referring to the miracle said to have been affected by her means.

Learning that the procession would pass her house, this good woman determined to seize the opportunity of showing yet once more her reverence and compassion for the Master. She had prepared a drink which should restore His strength, and, just as the group of which the Lord was the central Figure was passing her door, she issued from her house, to meet Him. "She was veiled," says Catherine Emmerich, "and a piece of linen hung from her shoulders; a little girl of nine years old followed her, and she waited as the procession advanced towards her, holding a vessel full of wine hidden beneath her mantle. Those who were marching at the head of the procession tried in vain to drive her back. Inspired by love and by compassion she forced her way, with the child clinging to her robes, through the mob, the soldiers and the archers, till she got close to Jesus, when she flung herself on her knees before Him, offering Him the linen, saying: 'Permit me to wipe the face of my Saviour.' Jesus took the linen in His left hand and applied it to His bleeding Face; He then pressed it a little between that hand and the right, which was holding the Cross, and gave it back to Seraphia, thanking her for it. She kissed what had now become a shroud, placed it under her mantle against her heart and rose from her knees."

Now Jesus, wishing to recompense Seraphia for this act of pious pity, had so used the linen cloth that, with the blood from His wounds which filled all the hollows of His face, His beard, His eyebrows and His nostrils, He had produced a perfect likeness of His features upon the surface of the cloth. No doubt the linen was in this case a kind of veil of very fine material such as Jewish women were in the habit of wearing on the head and shoulders. Saint Veronica treasured it up with pious reverence, handing it over later to the care of the Church, and it is now preserved and shown to the faithful at Rome.

"After Veronica had wiped the face of the Master," continues Catherine Emmerich, "the young girl timidly raised the vessel of wine towards Jesus, but the archers and soldiers with insulting words prevented Him from receiving that refreshment. It had been thanks only to her great boldness and to the fact that the crowd had for a moment arrested the progress of the procession that Seraphia had managed to offer the linen cloth. The Pharisees and archers, enraged at the halt and at the public homage rendered to

the Saviour, now began to goad and strike Him, while Veronica withdrew into her house. She had scarcely re-entered her chamber and laid the linen cloth on the table, before she fainted away and the little girl fell on her knees beside her, weeping burning tears. A friend of the house found them thus, with the linen cloth unfolded, on which was impressed the remarkably life-like likeness of the bleeding face of Jesus. Terrified at what he saw, the friend restored Veronica to consciousness and showed her the portrait of the Saviour. She fell on her knees before it crying: 'Now I will forsake everything, for the Saviour has honored me with a memorial of Him.'

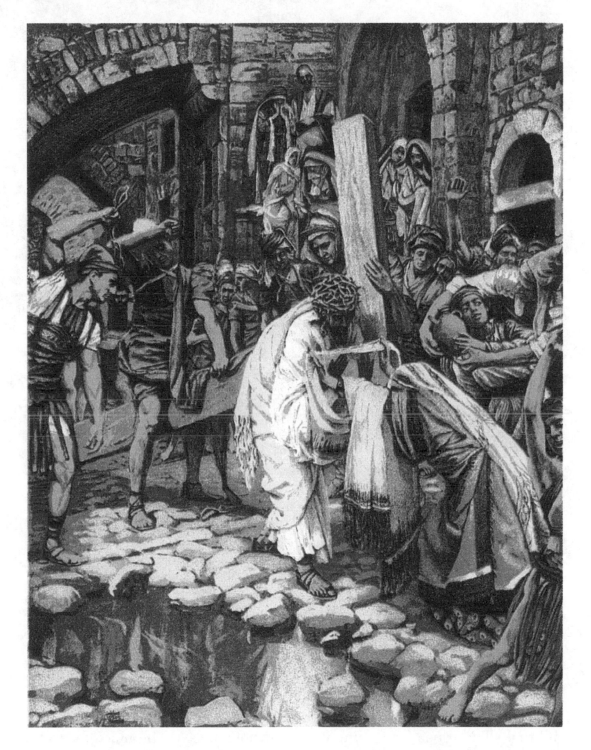

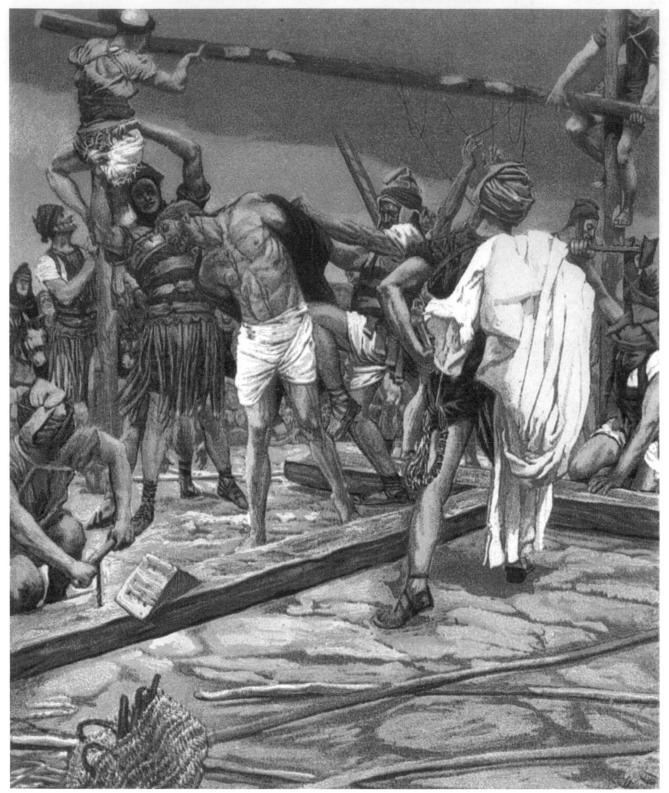

All is now ready. The wood of the Cross has been screwed together and made perfectly strong and firm. The ropes for raising it are in their places. The holes for the nails are bored. Jesus is now led forth and the stripping off of His garments begins. Of course the

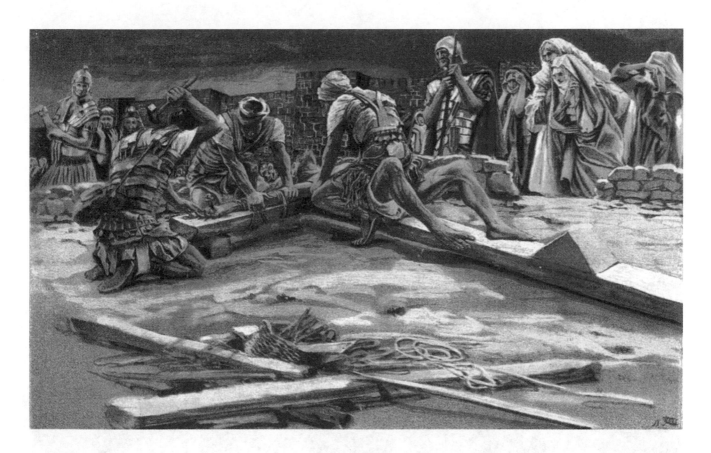

crown of thorns is the first thing taken off, "the vesture that is without scam" could only be removed by dragging it over the head of the Saviour. That "vesture" was soaked with the blood of the Sufferer and stuck to the unhealed wounds inflicted on Him in the scourging, so that when it was torn off much fresh suffering must have been caused by the pulling away with it of portions of lacerated flesh. The seamless garment removed, nothing was left but the short linen drawers that are worn by all Jews.

The Cross is now lying upon the ground; at least that is our idea, though we must add that the fact is open to question. According to some early writers, the instrument of execution was set up in a hole in the ground to begin with, and the condemned was then hoisted onto a seat and it was not until the body was thus placed that the hands and feet were nailed to the different portions of the cross. Many later writers are of opinion that this was the mode of crucifixion employed in the case of Our Saviour, and truth to tell, it is quite possible that it may have been so.

There is, however, a tradition which gives quite a different version of the course of procedure, and this tradition we propose to follow in our rendering of the terrible scene. It was with the hands that the horribly painful operation of the nailing began. As there was a danger that the weight of the body would tear away the flesh, the probability is that the limbs were first bound to the cross with cords.

We know from what we are told by Pliny, Xenophon, and several other early writers, that ropes were often used as well as nails. Lucian speaks in one sentence of *nodes nocentes*, or painful knots, and of *chalybem insertum manibus*, or nails driven into the hands. Later, following these ancient authors, the Fathers of the Church often referred

in their accounts of the execution of the Saviour to this double mode of fastening to the Cross, which they looked upon as a double martyrdom. It is evident that but for some such precaution the work could not have been properly done. In order to nail down the hands satisfactorily it was desirable first to bind the arms to the cross with cords. However patient and resigned the victim might be, the agony inflicted by the driving in of the nails must have caused spasmodic movements, which would have greatly hindered the executioners in their cruel task. It would be necessary to take this precaution when the condemned man struggled to get free, and, as this was very often the case, the practice of binding the arms to begin with naturally became universally customary.

The upper part of the body was also kept in place by a whole series of ligatures, which must indeed have added in a very marked degree to the sufferings of the condemned. If they were drawn tight enough to be of any use in binding the victim to the instrument of death, they must have eaten into the flesh. Also, by compressing the chest, they would have made respiration horribly painful. Additionally, the free circulation of the blood was checked. It is, however, certain that this supplementary suffering inflicted on the victim really saved him from even worse agony, and was, in the majority of cases, necessary to prevent accidents, such as could easily be foreseen if these various precautions were neglected.

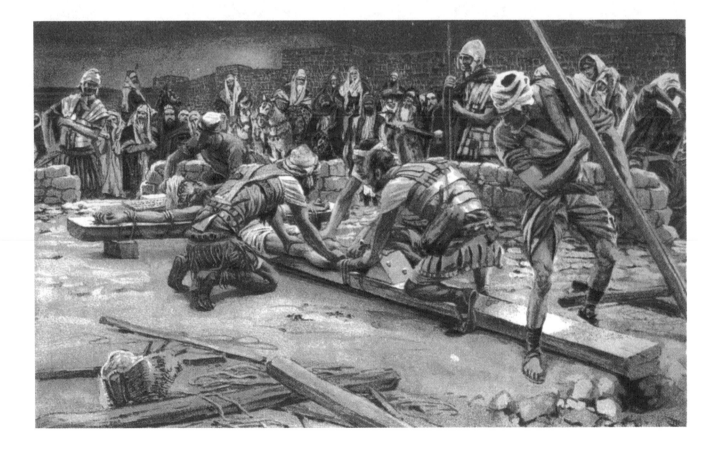

Without these cords supporting the body by being passed under the armpits, the victim could not long have retained his position. At the slightest slipping of the limbs, or the first swoon of the Sufferer, the knees would have bent, the head would have fallen forward and the body would have followed it, drawn out of the perpendicular by its own weight. Then the hands would have dragged away from the nails and a horrible fall would have broken the legs, which were held in position by the nail in the feet.

Such skilled workmen as the executioners in the service of Pilate, accustomed for a long time to their sinister task of crucifying malefactors, were not at all likely to risk any such accident. They are very sure to have bound the Saviour securely before they drove in the nails. Jesus, then, lies extended on the Cross, the body placed in the right position for His martyrdom; one arm is bound down to begin with, the hand extended so that the palm comes over the hole already pierced in the wood. Then one of the executioners drives the point of the huge nail in with vigorous blows from his hammer. As the first blow rings out, a groan escapes the lips of the Victim. From a little distance a cry replies to it, for Mary, the mother of the Sufferer, is standing with the other Holy Women at the foot of the Mount. She rushes forward as if to succor her divine Son.

The first nail driven home, the upper part of the body is stretched out horizontally and the second arm is made fast with ropes. Another nail is driven in, and one of the executioners flings himself astride upon the Sufferer to hold Him down. The next step is to bind the head and shoulders to the Cross, and then the legs, all quivering with anguish, are drawn down while the executioners put out all their strength to drive the third nail through both feet.

All this time the friends of Jesus are bewailing His terrible sufferings; they cling to each other and huddle together, wild with compassion and misery, and they listen to His moans, while at each stroke of the hammer they shudder afresh. They have gradually approached the scene of the awful drama. They had at first been stopped at the foot of the hill, but now they have managed to advance as far as the southern corner of Calvary to a small space just at the edge of the platform of Golgotha.

The crowd meanwhile has been pressing nearer. The Chief Priests and the leading Jews are close at hand, eager to witness everything. The sentinels have hard work to keep the space reserved for the execution clear of the curious crowds, and clear it must be kept if the difficult operation of the elevation of the Cross is to be successfully accomplished.

Are we to suppose that the crown of thorns was again placed on the head of Jesus at the final scene of His martyrdom? Yes, Origen, Tertullian, and many other writers of antiquity have asserted the fact, and their statement has never even been called in question by any authoritative contradiction. Even if, however, tradition had been silent on the point there would still have been every reason to believe that the crown of thorns was upon the Victim's head at His death. Those who wrote the title on the Cross, "Jesus of Nazareth, the King of the Jews," are not likely to have failed to leave to that King of Whom they were making sport the melancholy insignia of the royal dignity.

THE PARDON OF THE PENITENT THIEF

The tumult on Calvary is at its height. The crucified Victim is being insulted, the cowardly malice of the crowd is shamelessly manifested. The friends of Jesus endeavor to profit by the confusion to get nearer to the Cross. In the engraving they can be seen jostled hither and thither by the populace. Meanwhile, strange signs are already becoming visible in the heavens. The sun is becoming obscured in an unusual manner, a phenomenon causing the greatest terror. An unprecedented darkness is spreading through the town. Many of the spectators withdraw, not liking these omens, which they regard as sinister.

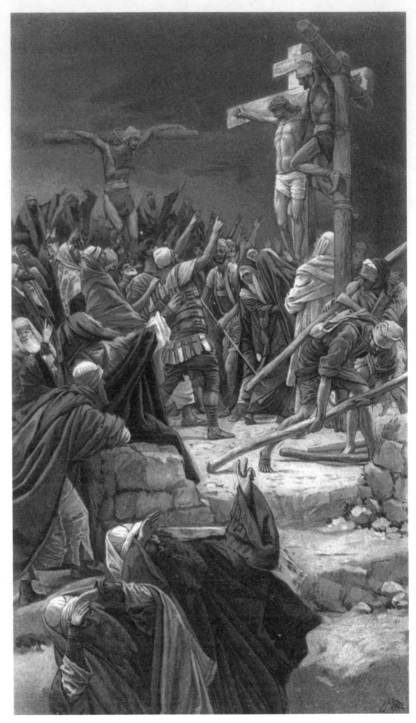

The result of this thinning of the crowd is that there is more room at the foot of the Cross. The faithful followers of Jesus are able to draw nearer. The devoted group at last succeed in getting quite close to the beloved Sufferer and can actually touch His feet. Mary Magdalen, who is quite beside herself with grief, will not leave the post she has taken up until the end.

The two thieves hang one on either side of the Saviour, but their attitude towards Him differs very much. One of them joins eagerly in the insults heaped on the principal Sufferer, his heart is filled with impotent rage, and his limbs are distorted by his evil passions. The other malefactor, however, is touched by the divine gentleness of the crucified Saviour, and when he finds that He remains silent, this second malefactor takes up His defense. Saint Luke is the only Evangelist to relate in detail this wonderful conversation, one of the chief pearls of the Gospel. There is something daring and grand in the intervention of this dying thief in the midst of his own agony on behalf of the crucified Redeemer.

"Dost thou not fear God," he says to his companion, "seeing thou art in the same condemnation?" This was an indirect but cutting reproach aimed as much at the Pharisees as at his fellow malefactor, and it alone would have been enough to enlist our sympathies, but what follows is still more admirable. It is rare indeed to find a sinner condemned to death acknowledging the justice of his condemnation. One cannot help being touched when reading this confession, which is at the same time a magnificent testimony to the power of the Master.

"And we indeed justly," the penitent thief goes on, "for we receive the due reward of our deeds: but this man hath done nothing amiss." This last assertion has led some to suppose that the penitent thief was a disciple of the Saviour who had drifted away from his divine Master. However, this supposition is not at all requisite for the comprehension of this speech.

The man, without being a disciple, must have heard Jesus spoken of in the course of His ministry. Later, he must have followed all the proceedings of the trial. He must have heard the verdict of Pilate. He must have known how the Accused had been sent back again by Herod. He must have been a witness of the supernatural incidents which took place during the Via Crucis, which alone would have been enough to convince him of the divinity of Christ. He therefore proclaims from his own cross his belief in the innocence of the Victim, and, this confession made, he has but to turn towards that Victim to share in the benefits won by the sacrifice. This is why, addressing the Saviour Himself, he appeals to Him in the humble yet sublime prayer: "Lord, remember me when thou comest into Thy kingdom."

It would have been impossible to express more forcibly his belief in the supernatural power of Christ. It was truly a most praiseworthy thing to be able to confess that belief at the moment when Jesus was abandoned apparently by God and man. Jesus, Who held His peace in the midst of all the insults of His enemies, would not leave such an act of faith without response. With His usual forcible expression, "Verily I say unto thee," He tells His fellow sufferer that his request is granted: "Today shalt thou be with Me in Paradise." The soul of the sinner, thus so suddenly redeemed, and finding itself so near to God, enters into a kind of ecstasy with his eyes fixed upon the face of his Master. In the various pictures which follow he will be seen still wearing that same expression, and nothing will again trouble the peace of this ransomed soul about to enter into eternal life.

They Parted His Raiment and Cast Lots

Now that the crowd has dispersed, the four hardened executioners are able to give their minds to their own affairs. The law gave them the garments of those put to death. They had not the slightest intention of renouncing their claim, and, as they were careful fellows, they also resolved not to injure their booty. They therefore refrained from cutting the seamless vesture, which would have made it of no use to anyone, but decided to begin by dividing the clothes into four equal parts and then to draw lots for them.

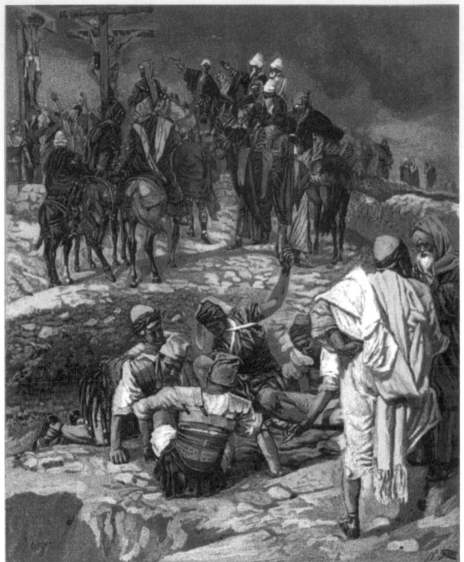

This is my idea on the subject. To make the four portions pretty equal, the mantle was first divided into two parts, an easy operation, as it was made up of several breadths. Then the whole was parceled out into four portions. The drawer of the first prize got the seamless vesture, the second the white robe already described, the third the sash, which was of finer material than the other raiment, probably with part of the mantle, while the fourth lot was made up of the sandals with the rest of the mantle.

Strictly speaking, perhaps the account given by Saint John should be interpreted somewhat differently. He says: "then the soldiers took his garments and made four parts to every soldier a part; and also his coat." This would seem to imply that this "coat" was drawn lots for separately, while the rest of the raiment was divided into four portions without it, though to which of the four claimants each of these four portions should fall was also decided by what the Evangelists call the casting of lots. The "coat" or "tunica" referred to by Saint John was "without seam," that is to say, it was "woven from the top throughout" in the same way as, according to Josephus, were the garments of the Priests.

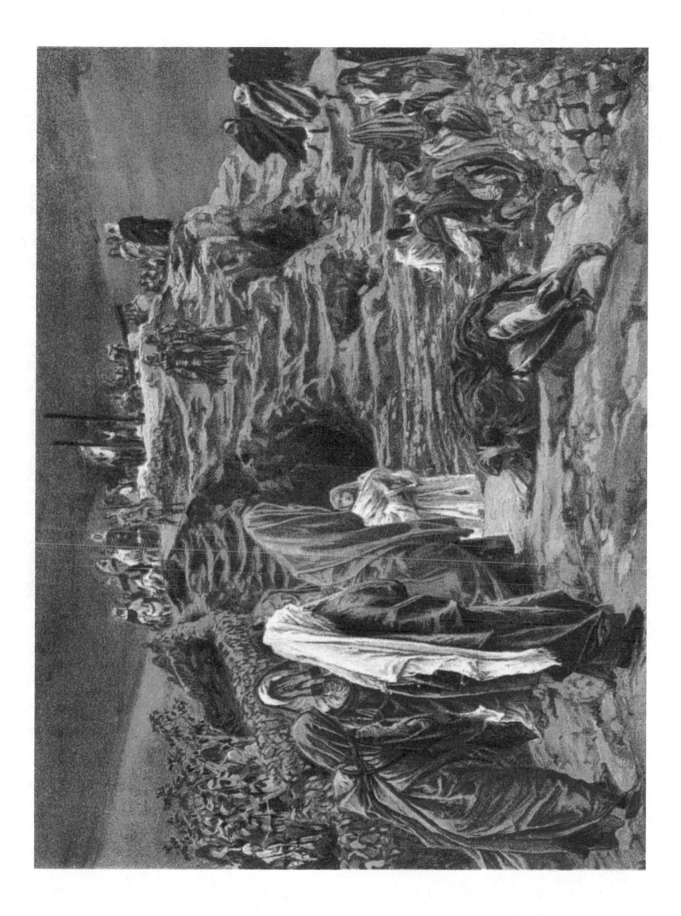

What Our Saviour Saw from the Cross

This is the idea I wish to express in my engraving: a momentary lull has occurred in the midst of the shouts and insults of the spectators, who are alarmed by the threatening signs in the sky and by the ever-increasing darkness. Now, from the top of the Cross on the summit of Golgotha, which dominates the town of Jerusalem, Jesus looks down on those beneath Him. The eyes of all, those eyes which are the windows of the soul, are fixed on Him. He sees every one who has aided in His condemnation, including the judge himself.

Down at His still bleeding feet He sees, as He bends His head, the weeping Magdalen, consumed with the fervor of her love and penitence. Beyond her stands His mother, gazing up at Him with an expression of ineffable tenderness, and Saint John, that most devoted of all the disciples, and Mary Salome, the latter weeping bitterly.

Farther away are the blasphemers, satisfied at last with the gratification of their malice, but on them, in the very midst of their triumph, has fallen fear and astonishment. In some cases, perhaps, faith in the Redeemer may be already beginning to develop, and stubborn hearts may be touched with the all-powerful grace of God.

Yet a little farther off, beyond the wall of the garden of Joseph of Arimathea, is the sepulchre which that same evening is to receive the body of the Saviour. Beyond the trees the dying Sufferer can make out groups of the more timid of His followers, the disciples who, in spite of their love for the Master, dare not approach nearer until the darkness shall be so great that there will be no danger of their being recognized. So profound is the silence that even the distant murmur of voices from the city and the blasts of the trumpets from the Temple can scarcely be heard.

Far away down below rises up a great column of dense smoke from the Altar of Burnt Sacrifice. The wind is in the East and comes from the direction of the Dead Sea, laden with the mixed fumes of incense, burning meat and melting fat. The air is heavy and oppressive, while all around is wrapped in a mantle of the deepest gloom.

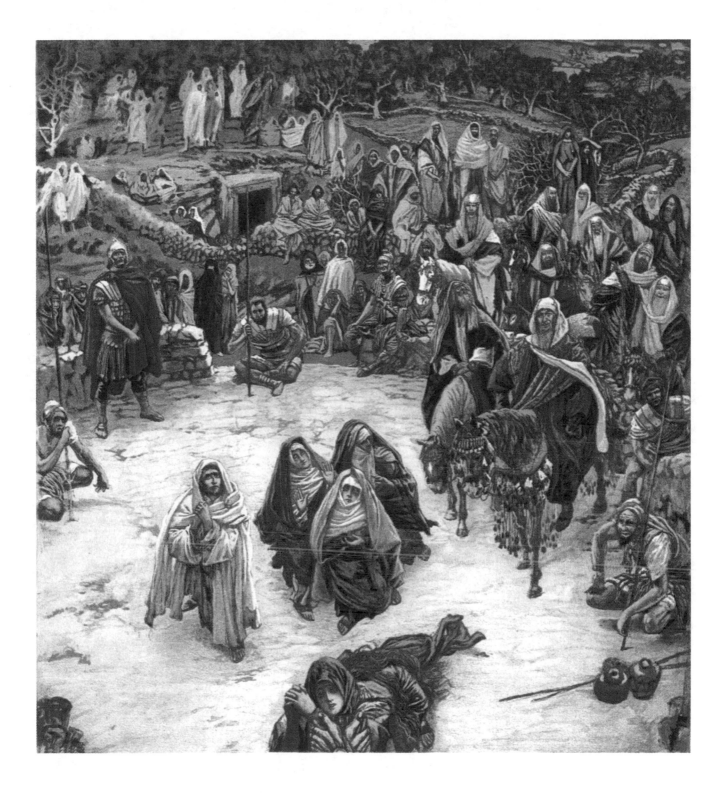

93

"Mater Dolorosa"

We all know the beautiful and pathetic hymn dedicated by the medieval Church to the Virgin Mother:

At the Cross her station keeping,
stood the mournful Mother weeping,
close to Jesus to the last.

Through her soul His sorrow sharing,
all His bitter anguish bearing,
now at length the sword had pass'd.

Oh! How sad and sore distressed
was that Mother highly blessed,
of the sole begotten one!

Christ above in torment hangs;
she beneath beholds the pangs
of her dying glorious Son.

Is there one who would not weep,
whelm'd in miseries so deep,
Christ's dear Mother to behold?

Bruis'd, derided, curs'd, defil'd,
she beheld her tender Child
with the cruel scourges rent;

Saw him hang in desolation,
for the sins of His own nation,
till His spirit forth He sent.

O thou, Mother, fount of love,
touch my spirit from above,
in my heart each wound renew,
of my Saviour crucified.

Let me share with thee His pain,
Who for love of me was slain,
Who for me in torments died.

Let me mingle tears with thee,
mourning Him Who died for me,
all the days that I may live.

By the Cross with thee to stay,
there with thee to weep and pray,
this I thee entreat to give.

The first strophe of this hymn has decided once for all in the popular imagination the attitude of Mary at Golgotha: *Stabat*, it says, or, she stood. It is, however, difficult to believe that she really maintained a stoical attitude. Mary was a mother, and the strength given her from God would not spare her from the agony she must have suffered as she beheld her Son

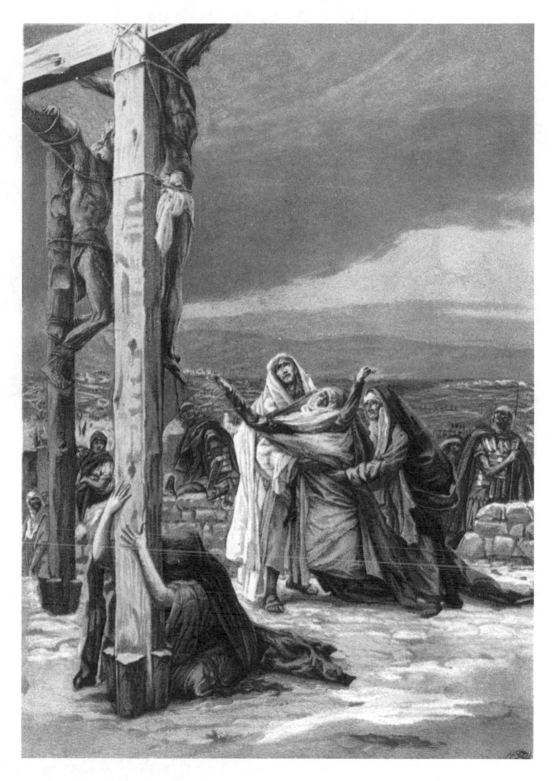

crucified before her very eyes. Jesus had prostrated Himself upon the ground at Gethsemane, and Mary doubtless sunk down more than once on Calvary, and needed the ministrations of Saint John and the Holy Women to support and restore her. It is even said that once she was led by them away from the platform, quite overcome and trembling with anguish. But for this absence of His Mother, temporary though it was, it would have seemed as if Jesus would have been spared one terrible ordeal: that of finding Himself alone, forsaken alike, apparently, by Heaven and earth.

It is the ninth hour, that is to say, three o'clock in the afternoon, and the Jews, fancying that the death of their Victim will be delayed for some time longer, are beginning to withdraw one after the other. All of a sudden, under stress of a supreme agony, convulsing alike body and soul, Jesus gives utterance to that cry of anguish, the most heartrending which ever resounded upon this earth:

"My God! My God! Why hast Thou forsaken Me?"

Mary flings herself forward towards her dying Son and all the other mourners resume their places. Mary Magdalen is still at the feet of the Lord. It is worthy of notice that this dying cry of Jesus is a quotation from the 22nd Psalm, the whole of the first part of which—so extremely precise is the prophecy it contains—might be an actual description of the tragic drama which culminated on Calvary. Now this fact makes it difficult enough to understand the mistake made by the spectators, who were most of them Jews well acquainted with the Scriptures. "Behold, he calleth Elias!" they scornfully exclaimed. Truly a strange remark from the lips of Children of Israel! Some authors are of opinion that the Jews willfully travestied the cry of their Victim by a mocking play upon words. But who could possibly believe that any Jew would have ventured to turn into ridicule in a manner so insolent the deeply reverenced name of Jehovah? It is far more natural to suppose that the words uttered by Jesus were not clearly heard, and that it was this which led to the unintentional mistake, with the ironical remarks quoted in the sacred text.

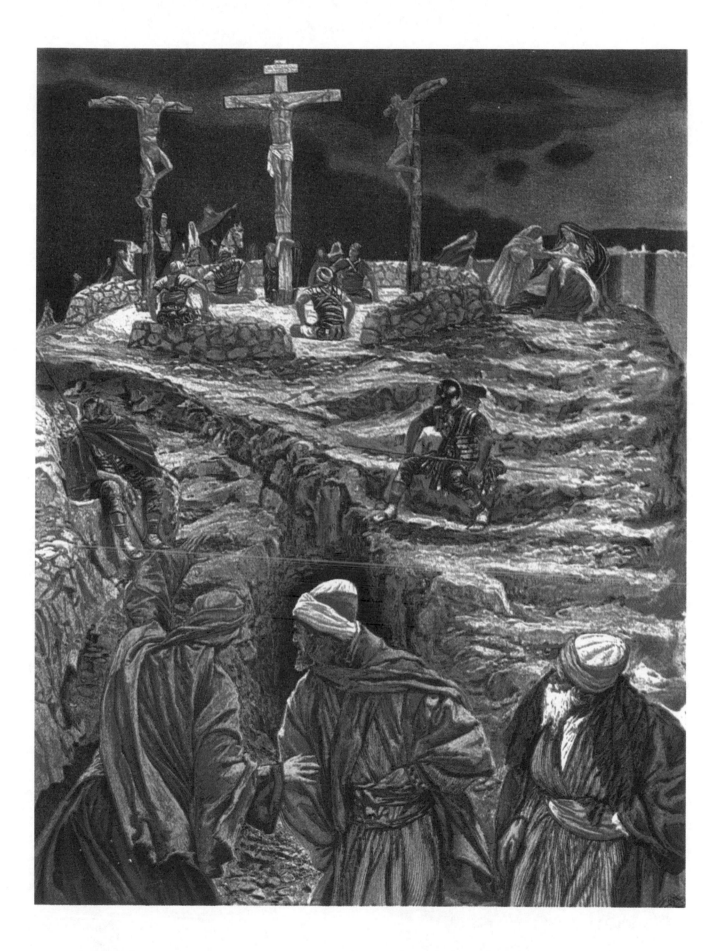

"It Is Finished"

This last cry was one alike of obedient submission and of triumph. In one brief, telling sentence it summed up the whole of the work of Jesus Christ as foreshadowed by the various types and foretold by the prophecies of the Old Testament now fulfilled. It is the final completion of the Covenant between the Son of Man and God the Father, and between them and the human race. All is finished now! The work is done. The prophecies are accomplished. There are no more insults to be submitted to now, no more tortures to endure; the Man of Sorrows has gone through all the suffering to which He was foredoomed, and, humanity being through His sacrifice reconciled to God, there is nothing left for Him to do but to die. It is, then, at this supreme moment that He rallies His strength for an instant to proclaim to the world in a thrilling voice: "It is finished."

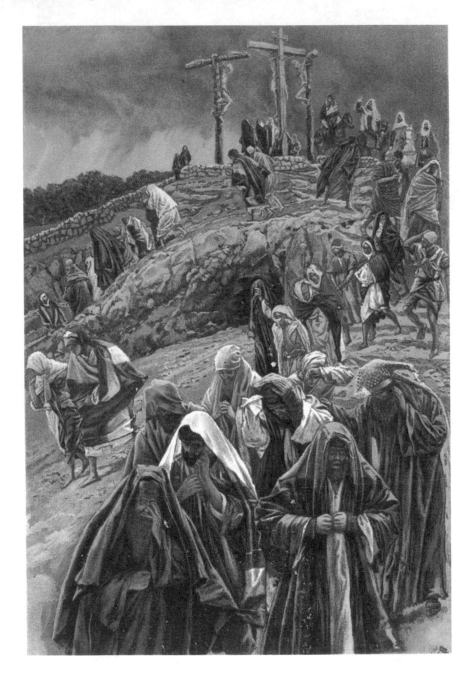

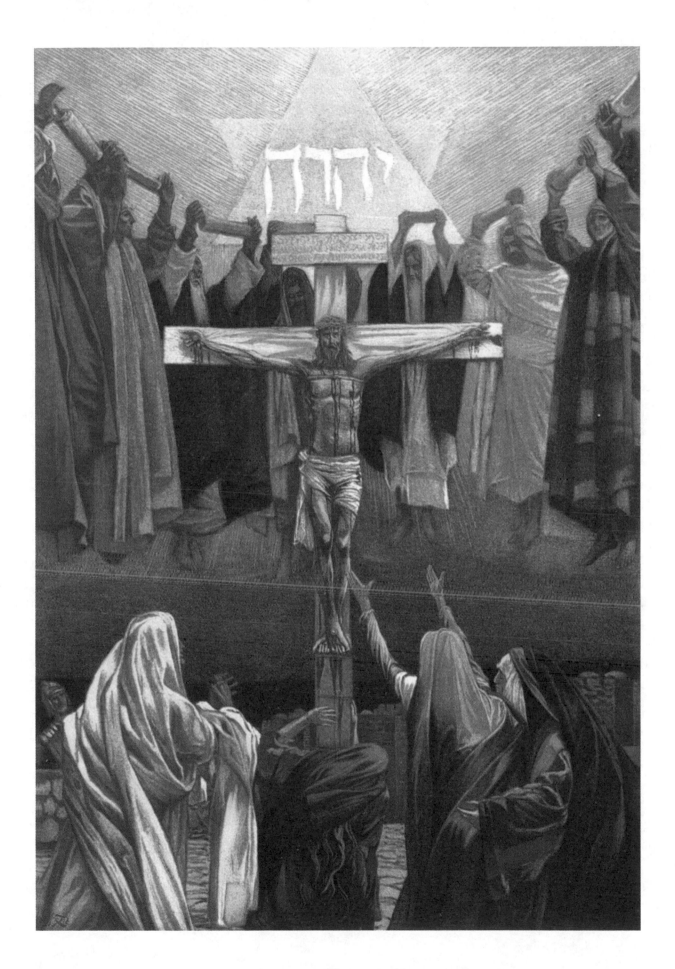

JESUS ALONE ON THE CROSS

The day which has been so crowded with events is drawing to a close. The spectators have left Calvary and the two thieves have already been taken away. This was quickly accomplished, for all that was needed was to undo the ropes which kept the bodies in place, to fling those bodies into some hole nearby and then to cover them over with stones, of which there were plenty about. In the case of Jesus a special request had been made and the orders of Pilate were being awaited. It was Joseph of Arimathea, according to Saint Mark "an honourable counsellor," that is to say, a member of the great Council or Sanhedrin, and a secret disciple of Christ, who had gone to crave the body of the Master.

During this pause Saint John and Mary Salome went into the town to collect all that was needed for the performance of the last melancholy offices for the sacred remains and for burying them in accordance with the usual rites. Already, finding the place deserted, and attracted by the smell of blood, the dogs, which swarm in Eastern towns, are prowling about Calvary. They run to and fro sniffing for the bodies of the thieves, while in the air above hover eagles and vultures, wheeling slowly round, ready in their turn to pounce upon the quarry. The Mother of Jesus, who still stands, and Mary Magdalen who has fainted away, at the foot of the Cross, can neither of them leave. Even if they could believe Him to be dead they could not tear themselves from the spot, but feel as if they must remain there forever. Absolute silence reigns around Golgotha. A thousand reasons keep the crowds away from it and prevent isolated passers-by from approaching.

To begin with, the Sabbath is close at hand. It commences at sunset, after which all Jews will be occupied and absorbed with the ceremonies of the Passover. Moreover, dead bodies are looked upon as impure, and everyone would avoid being near them on the eve of so solemn a feast. Lastly, and above all, the extraordinary events which occurred on Calvary but a few hours previously have led to the spot being dreaded, and all the spectators have fled from it. A few belated travelers at the most glide rapidly along the walls of rough stone, their furtive steps seeming rather to intensify than to disturb the loneliness of the scene. Truly gloomy is the appearance of Calvary! Two empty crosses stand out against the sky, while the third still bears the body of the divine Victim, rigid in the immobility of death.

At His feet are two silent women and all around Him is the desert. The darkness has gradually dispersed and the weather is brightening somewhat, though it still looks threatening. A pale sun lights up the Mount of Olives, at the foot of which is the town, now in all the ferment of excitement usual at the time of the great feasts. The air is laden with a penetrating perfume; it is the scent of the incense, of which large quantities are being burnt in the Temple. At regular intervals the sound of the trumpets rings out, now in short, now in the long drawn-out blasts, summoning the worshipers to the evening ceremonies and regulating the order in which successive groups are allowed to enter the Temple.

Mary and the Magdalen remain motionless, utterly absorbed in their grief. What have they left to do but to wait? In any case, however, they could not leave the Lord. When Jesus was deserted by all others, these two women were ever true to Him.

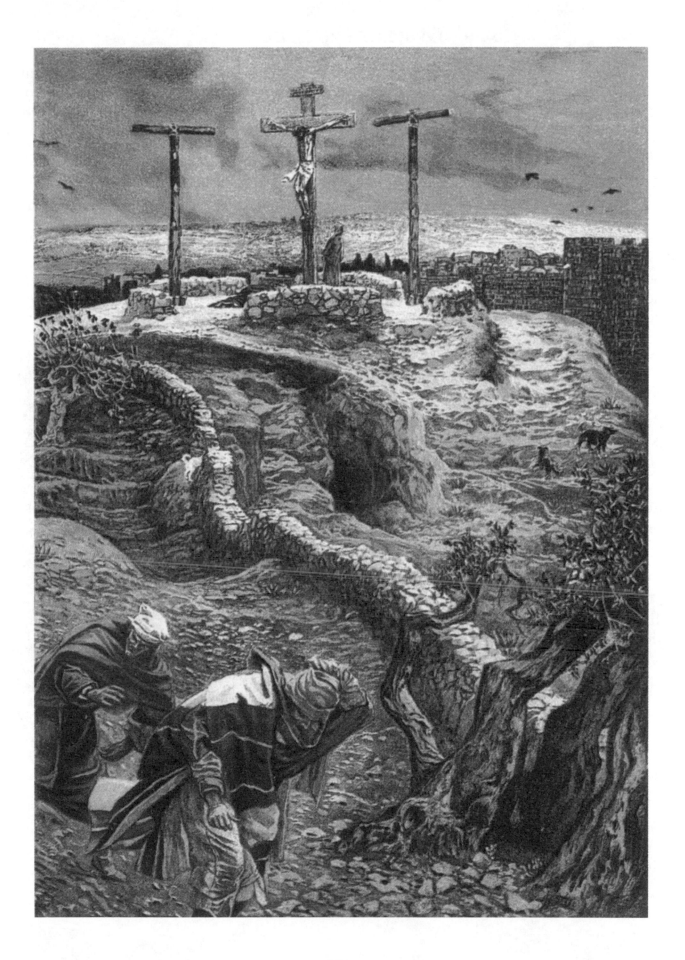

THE DESCENT FROM THE CROSS

Calvary is hushed in silence now, and instead of the tumult of a short time ago nothing is heard but stifled sobs. The necessary orders for removing the beloved Body from the Cross as rapidly as possible are whispered from one to the other. Nicodemus and Joseph of Arimathea noiselessly make all the necessary arrangements for the delicate operation. This is how it was probably managed.

To begin with, a long band of some material was placed across the chest and under the arms of Jesus, which band, passing over the crossbeam on either side of the title, and kept in place from behind by those who stood on the ladders, served to uphold the body for a moment or two when the cords were removed. The nails were then taken out of the hands. The arms were gently drawn down against the livid body, still bearing on it the marks of the blows, the injuries sustained in the various falls, the scourgings, and the bonds. Then, the body being still kept in place against the Cross by the band, the nail was removed from the feet, and the centurion reverently received in swathing cloths the legs of the Saviour.

By gradually loosening the band of stuff upholding and wrapping round the sacred Form it is now possible to let that Form slowly glide into the arms of Mary, Saint John and the Magdalen, who stand waiting to receive it. Their hands are swathed in linen brought from the town. It is only with the deepest reverence that they venture to touch the sacred remains. Their sobs have ceased and a solemn silence reigns on Golgotha.

Now that the face of Jesus is brought close to them they can gaze on it unchecked and see how the blood, which has now turned black, fills all the cavities, contrasting vividly and terribly with the pallor of the skin. The nostrils, the mouth, the eyes are alike filled with blood, the hair beneath the crown of thorns is soaked with it. The ears are quite hidden by the great clots which have collected about the temples. The half-closed eyes are suffused with blood, yet through the partial veil they seem to retain their tender expression.

It is Saint John who mentions the fact of the presence of Nicodemus, and his reason for so doing is betrayed by the expression he uses: "And there came also Nicodemus," he says, "which at the first came to Jesus by night." There is something very striking in the contrast thus suggested.

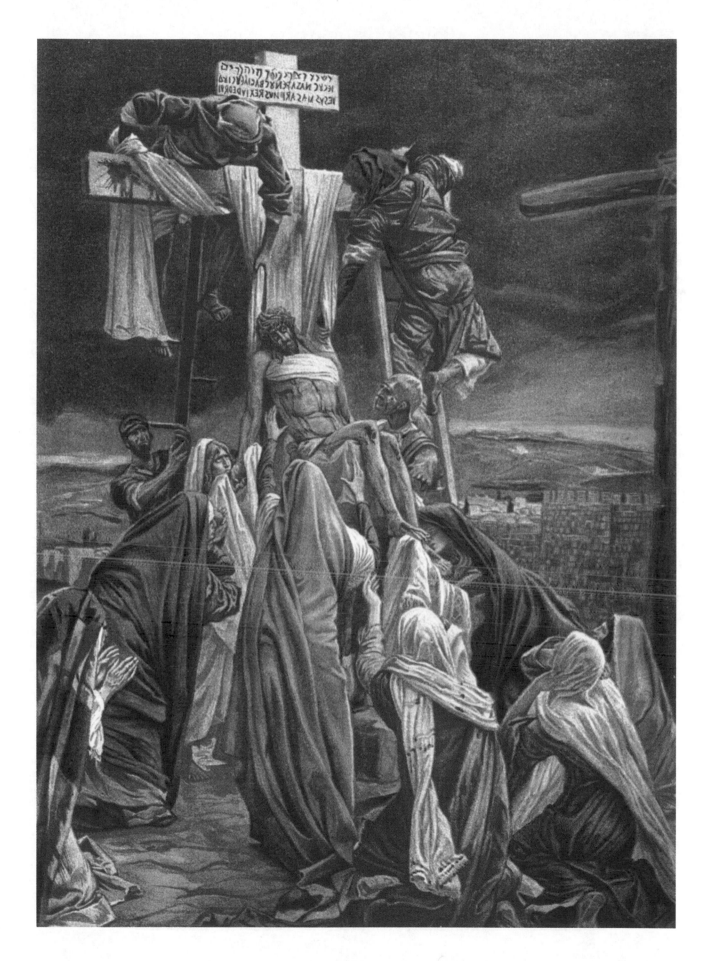

The Body of Jesus

The head, face and arms, with the upper part of the sacred body, have been washed with lukewarm water, dried and anointed with spices by the Mother of Jesus. The mourners then prepare to descend to the foot of Mount Calvary, where, near the entrance to the so-called cave of Melchizedek, was a piece of rock flat enough to receive the corpse. There the disciples will complete the work begun by Mary, washing the feet, the legs and the lower part of the body. They will then anoint with spiced unguents the wounds, the bruises, and the gaping holes made by the nails.

Now that the body of Jesus rests in the shroud, upheld by His friends, it seems imbued with a calm and majestic grandeur. The hair and beard are carefully arranged. The limbs seem to be stretched out in natural repose, and the features are restored to something of the beauty which rendered the Saviour so attractive in life. The procession is soon formed. The sacred burden is carried by Nicodemus, Joseph of Arimathea, Saint John, and the centurion. The Virgin follows, supported by her nearest relations, while Mary Magdalen, who is scarcely able to walk, follows her. The group of Holy Women follow the chief mourners, chanting Psalms broken every now and then by their lamentations, which they no longer make any attempt to disguise.

The crown of thorns, with the sponges soaked with the Precious Blood and the vessels containing the water which has been used to wash the sacred corpse, are set apart, protected by a veil thrown over them. As for the nails which had fastened Jesus to the instrument of His death, they were left with the Cross and its title. It would have been against the law to remove any of these things, for they were the property of the Roman authorities.

It is to these scruples that we must, as it appears to me, attribute what would otherwise appear to be the inexplicable negligence of allowing the Cross and the nails to be buried beneath the rubbish which accumulated during the long centuries succeeding the death of Christ.

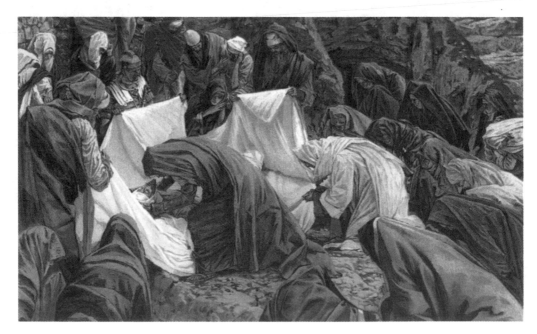

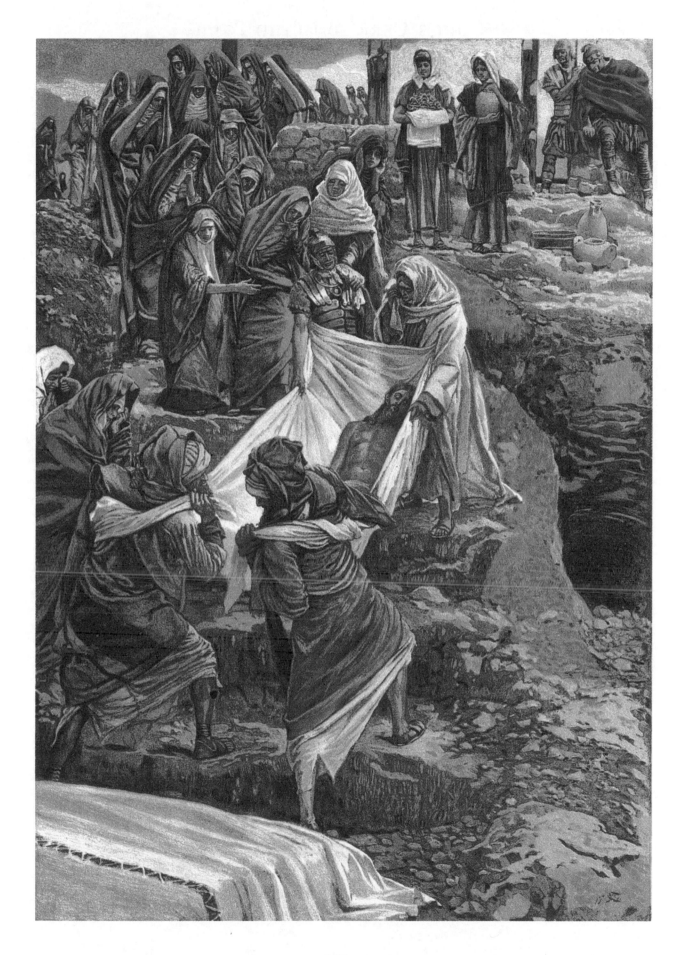

CHRIST CARRIED TO THE TOMB

The new sepulchre given by Joseph of Arimathea is close at hand, not more than a stone's throw off the flat piece of rock where the washing and embalming of Jesus have taken place. Behind this spot, however, the ground suddenly rises, while the wall enclosing the Garden makes it impossible to go straight to the tomb. The procession is therefore compelled to make a slight detour to avoid places so steep that the sacred burden would be shaken in a manner not at all consistent with the reverence due to it. The ground was not then as level as it became later.

The sun is setting. Haste must be made, for the Sabbath will very soon begin and the whole ceremony ought to be completed before that. This will explain how it was that there was something left to be done on the Sunday morning, and why the Holy Women will return to anoint yet again the body of the Lord.

The sky is clear. All the serenity of an evening in spring is once more restored. There is no wind, the smoke of the torches lighting up the tomb ascends straightly, the women shrouded in their mourning garments follow singing psalms, the sweet sound of their voices being heard afar off through the still air. The body of the Master is borne upon a kind of litter carried on their shoulders by Saint John, Joseph of Arimathea, the centurion, and Nicodemus. Then comes Mary, accompanied by the Holy Women.

On leaving the Stone of Anointing, the procession turns in the direction of the town. Then it skirts along the spot where the crosses are lying, reaches the garden, and passes beneath a few olive and fig trees, the shadows of which gradually deepen and lengthen. Finally it arrives, after having made an almost complete circuit of Golgotha, at the entrance to the Sepulchre, which is reached by going down a few steps.

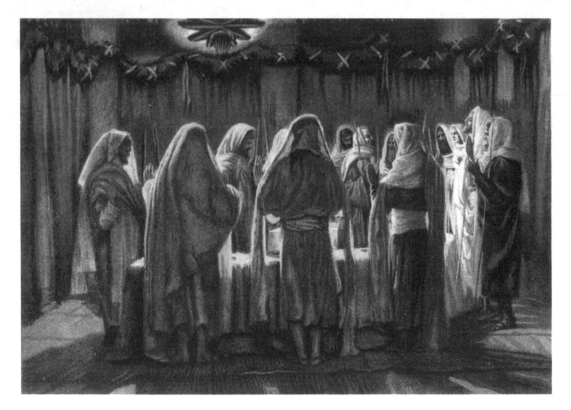

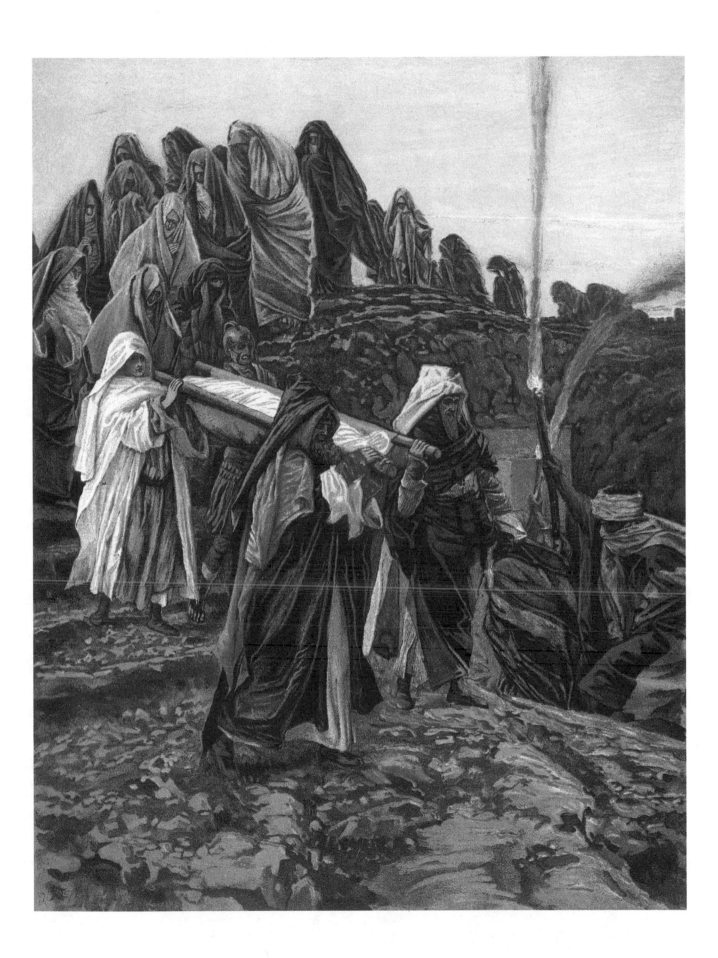

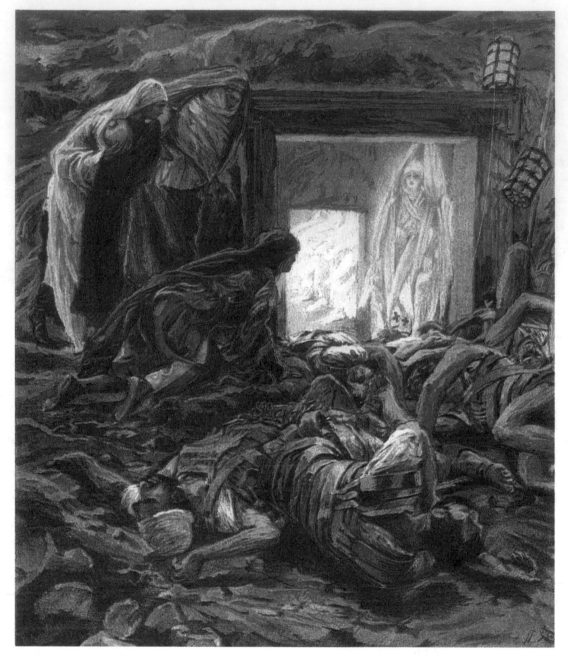

The glorified Christ escapes from the tomb. Silently He rises. His wounds shine luminously. His body, now triumphant over death, is no longer subject to the laws to which it had previously submitted. In a moment He will disappear in space to reappear according to His promises. The sudden terror inspired by the earthquake, the blinding radiance which issues from the tomb and the apparition of the angel seated within it plunge the guards into a kind of cataleptic* state. As the sacred text tells us, "They became as dead men." The Evangelist notes especially the effect produced on the soldiers by the sight of the angel: "for fear of him," he says, "the keepers did quake" as though a thunderbolt had fallen. They seemed to see the lightning flash and a terrible meteor flinging itself upon them to crush them to powder.

*trancelike

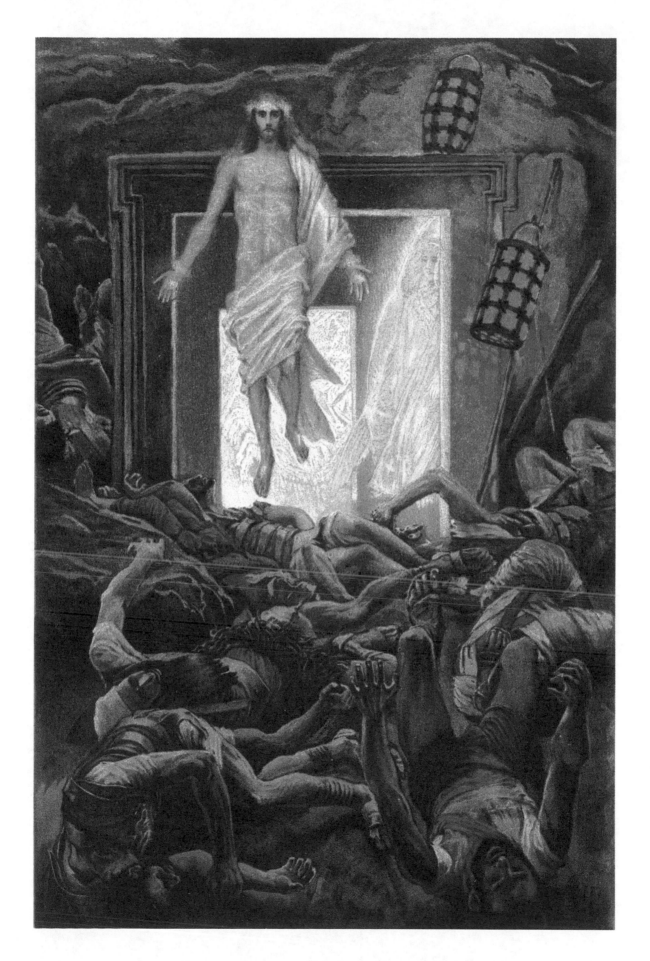

Like our books?

You might like our program, too. Seton Home Study School offers a full curriculum program for Pre-Kindergarten through Twelfth Grade. We include daily lesson plans, answer keys, quarterly tests, and much more. Our staff of teachers and counselors is available to answer questions and offer help. We keep student records and send out diplomas that are backed by our accreditation with the Southern Association of Colleges and Schools and the AdvancEd Accreditation Commission.

For more information about Seton Home Study School,

please contact our admissions office.